C000193683

LEITH
THROUGH TIME
Jack Gillon &
Fraser Parkinson

AMBERLEY PUBLISHING

Acknowledgements

We would like to thank a number of people for help with the book.
Huge thanks to all those who contributed images: Archie Foley, Joanne Baird, Steven Saunders, Bill Robertson, Jennifer Wells, Doreen McTernan, Trevor Roy and Bill Scott.

The friends of the Spirit of Leithers (www.facebook.com/pages/The-Spirit-of-Leithers) and Lost Edinburgh (www.facebook.com/lostedinburgh) Facebook pages are a regular source of inspiration. Particular thanks to Spirit of Leithers Frank Ferri and Graham Whyte, and to the other hundreds of regular contributors.

Special thanks to our friends, David McLean and Archie Foley.

Thanks to Tom Furby and Tom Poad at Amberley Publishing.

Last, but not least, Emma Jane and Yvonne, who tolerate our sometimes obsessive interest in all things *Old Leith*.

Jack and Fraser

First published 2014

Amberley Publishing
The Hill, Stroud
Gloucestershire, GL5 4EP
www.amberley-books.com

Copyright © Jack Gillon & Fraser Parkinson, 2014

The right of Jack Gillon & Fraser Parkinson to be identified as the Authors of this work has been asserted in accordance with the Copyrights, Designs and Patents Act 1988.

ISBN 978 1 4456 4064 8 (print)
ISBN 978 1 4456 4095 2 (ebook)

British Library Cataloguing in Publication Data.
A catalogue record for this book is available from the British Library.

Typesetting by Amberley Publishing.
Printed in the UK.

Introduction

Leith was first established on the banks of the Water of Leith, at the point where the river entered the Firth of Forth. The first historical reference to the town of Leith dates from 1140, when the harbour and fishing rights were granted to Holyrood Abbey, by David I. The early settlement was centred on the area bounded by the Shore, Water Street, Tolbooth Wynd and Broad Wynd.

Leith became Edinburgh's port in 1329 when King Robert I granted control of the town to the Burgh of Edinburgh. Further Royal Charters during the fifteenth century gave Edinburgh the rights to land adjoining the river, prohibiting all trade and commercial activity by Leithers on the ground owned by Edinburgh.

Leith constantly features in the power struggles that took place in Scotland, and the battles, landings and sieges of Leith have had an influence on its development. It was attacked by the Earl of Hertford in 1544 during the Rough Wooing – his mission was to arrange a marriage between the young Mary, Queen of Scots, and her English cousin, later Edward VI. Three years later, Leith was pillaged after the defeat of the Scottish army at the Battle of Pinkie. Immediately following this, Mary of Guise, the Roman Catholic Regent of Scotland, moved the seat of government to Leith and the town was fortified.

In the second half of the eighteenth century, regular streets, including Bernard Street and Constitution Street, were built on the edges of the town, and Queen Charlotte Street was cut through the medieval layout. Leith became a fashionable seaside resort, which, as early as 1767, included a golf clubhouse built by the Honourable Company of Edinburgh Golfers at the west end of the Links.

Leith expanded greatly during the nineteenth century, associated with railway building and the growth of the docks. Port-related industries and warehousing also grew rapidly during this period. This contemporary description paints a vivid portrait of the Port at the time:

> Leith possesses many productive establishments, such as ship-building and sail-cloth manufactories ... manufactories of glass ... a corn-mill ... many warehouses for wines and spirits ... and there are also other manufacturing establishments besides those for the making of cordage for brewing, distilling, and rectifying spirits, refining sugar, preserving tinned meats, soap and candle manufactories, with several extensive cooperages, iron-foundries, flourmills, tanneries and saw-mills.

In 1833, Leith was established as an independent Municipal and Parliamentary Burgh with full powers of local government. Leith expanded as massive warehouses and additional docks were built: the Victoria Dock in 1851, the Albert Dock in 1881 and the Imperial Dock in 1903.

After the passing of the Leith Improvement Act in 1880, many of the slums and most of the sixteenth- and seventeenth-century buildings were cleared away. This coincided with programmes of major tenement development – in particular the building of dense tenement blocks over the fields between Leith Walk and Easter Road.

In 1920, the town was amalgamated with Edinburgh in what have been described as controversial circumstances. By the time of the amalgamation, Leith contained its successful port, significant industrial enterprises, shipbuilding yards, warehouses, bonds and a population densely packed into ageing tenements and housing stock.

Following the First World War, the number of shipyards was reduced to one and the stream of pre-war trade dwindled. Through the inter-war years, Leith had high unemployment. However, the population of Leith was still around 80,000 at the start of the Second World War.

The 1950s brought the final days of what older Leithers would describe as the heart of Leith. The brimming tenements, shops and small workshops of the 1950s along the old and ancient thoroughfares in the heart of Leith were destined for redevelopment. The Kirkgate, St Andrew Street, Tollbooth Wynd, Bridge Street and many more would disappear in the coming decade.

After decades of industrial decline, slum clearance and depopulation in the post-war era, culminating in the major redevelopment of the Sixties, Leith gradually began to enjoy an upturn in fortunes in the late 1980s. The emphasis moved to urban renewal, community needs and the conservation of Leith's historic buildings.

The town retains a passionate sense of individuality, and its people a proud sense of identity. Today, Leith is a thriving port and cruise line destination with many excellent hotels, restaurants and bars. It is also the base of the Royal Yacht *Britannia* and the home of Scotland's Civil Service at Victoria Quay.

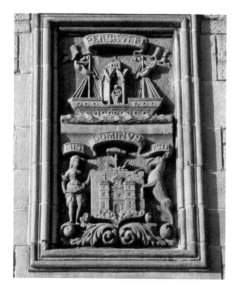

The seal of Leith – carved in stone on the Malmaison Hotel, which was previously the Sailors' Home.

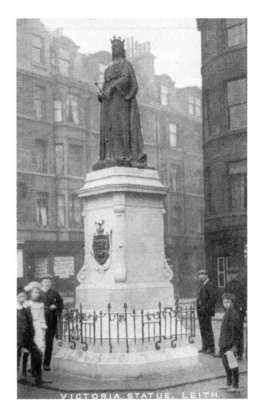

Statue of Queen Victoria, Foot of Leith Walk
The statue of Queen Victoria at the 'Fit o' the
Walk' is one of Leith's best-known landmarks.
The bronze statue, designed by John Stevenson
Rhind, was unveiled in front of a crowd of
20,000 people on 12 October 1907, by Lord
Roseberry. It is a memorial to the many Leithers
of the Royal Scots who fought in the Boer War.
In 1913, plaques were added to the plinth to
commemorate Queen Victoria's visit to Leith
in September 1842. Over the decades, many
Leithers have gathered to exchange news under
the watchful gaze of the Queen. The statue has
been moved twice, in 1968 and in 2002.

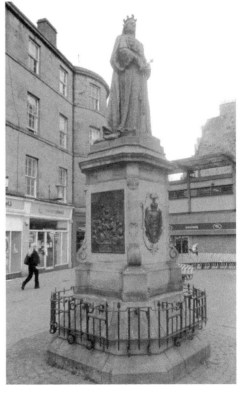

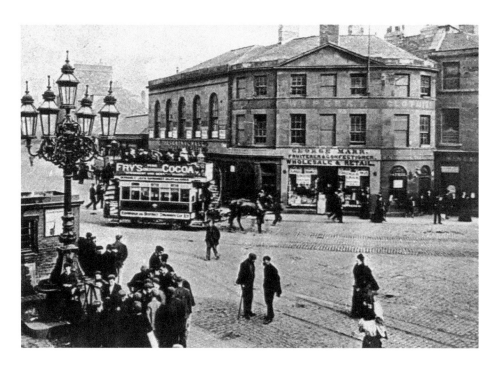

Leith Central Station, Great Junction Street

Leith Central railway station was the terminal station of the Leith branch of the North British Railway. It was opened on 1 July 1903 and closed to passenger traffic on 7 April 1952. The outstanding feature of Leith Central station was its size, which took up a complete town block running all the way through from Leith Walk to Easter Road, most of which was covered by a huge steel-framed roof. The four platforms were 15 feet above street level. The inset shows a horse-drawn tram heading up Leith Walk, passing under the station clock. The image above shows the corner of Leith Walk and Duke Street in 1898 before the station was built, featuring George Marr's fruiterer and confectioner. The horse-drawn tram, advertising Fry's Cocoa, was bound for Gorgie.

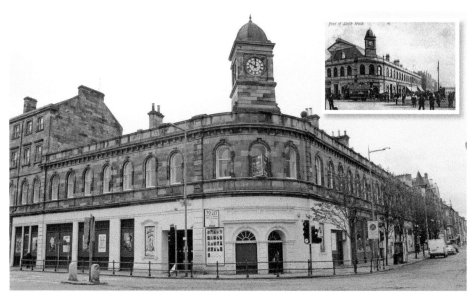

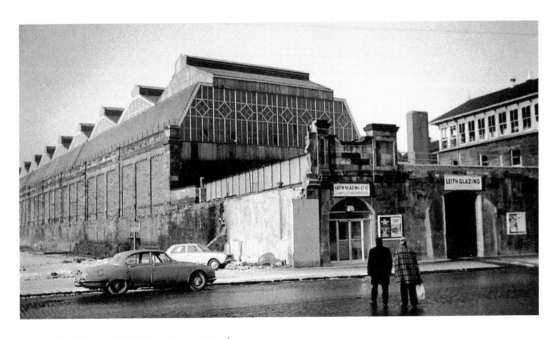

Leith Central Station, Easter Road
Although the passenger service had ceased in the 1950s, Leith Central station continued to be used as a diesel maintenance depot until its closure in 1972. Shown here is the location of the Easter Road Bridge that once spanned the road below – the sole entrance and exit for all rail traffic. In its final years, the derelict station was much used by drug addicts and the inspiration for the ironic title of Irvine Welsh's book *Trainspotting*. The train, *The Gordon Highlander*, was withdrawn from service in 1958, and it is shown exiting the station on a steam enthusiasts weekend tour in 1965. (*Photograph courtesy of Bill Robertson*)

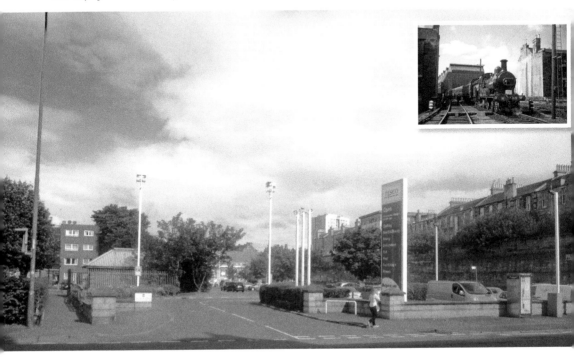

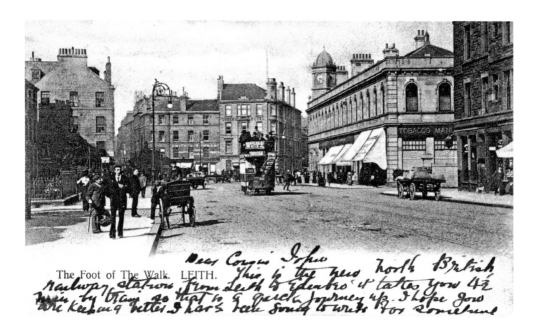

The Foot of The Walk. LEITH. *Dear Cousin Sophie, This is the new North British Railway station from Leith to Edinburgh it takes you 4½ min by tram so that is a quick journey up. I hope you are keeping better I have been some to write for some time*

The Foot of Leith Walk

The Foot of Leith Walk was still almost entirely rural in 1785. Scattered development on both sides of Leith Walk followed in the late eighteenth century and early nineteenth century. The well-known 'Central Bar' was incorporated into the structure of the station facing on to Leith Walk, near the clock tower, in 1902. The public house interior included tiled murals of sporting scenes. The eighteen-storey high-rise Kirkgate House, dating from the 1960s, is prominent in the new image. The inscription on the front of this postcard of the Foot of the Walk reads: 'Dear Cousin Sophie, This is the new North British Railway Station, from Leith to Edinburgh it takes you 4½ minutes by train so that is a quick journey up. I hope you are keeping better. I have been going to write for some time.' The reference to the station being new dates the card to around 1903.

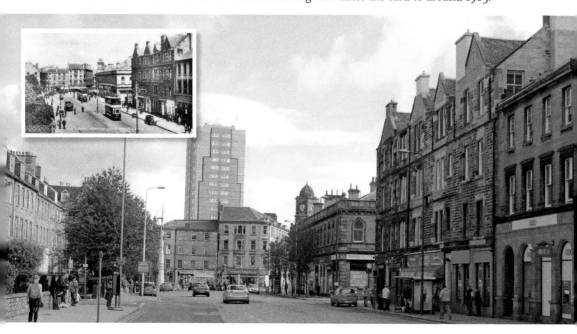

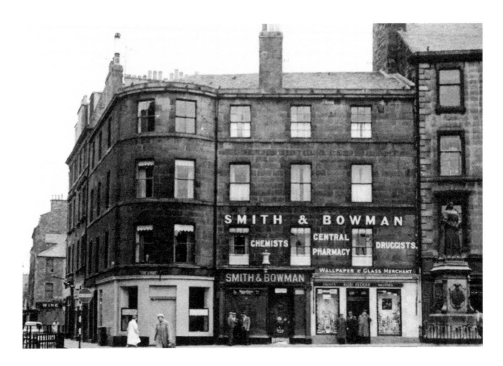

Kirkgate at the Foot of the Walk

So many old Leithers lamented the passing of the old Kirkgate. Here we see the contrasts of time and fashion at the entrance point to that ancient thoroughfare. The razing of the old Kirkgate in the 1960s led to the building of the new Kirkgate shopping centre. Despite her unamused expression, not even Queen Victoria was unaffected by progress, having been moved in 2002 to provide more space for the new steel sculpture, a whale's tusk. The familiar shops of Smith and Bowman, and Woolworths, stood for decades at the foot of Leith Walk.

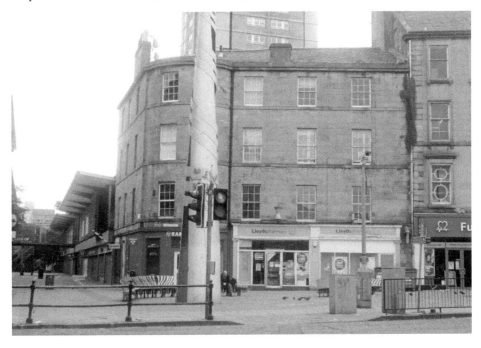

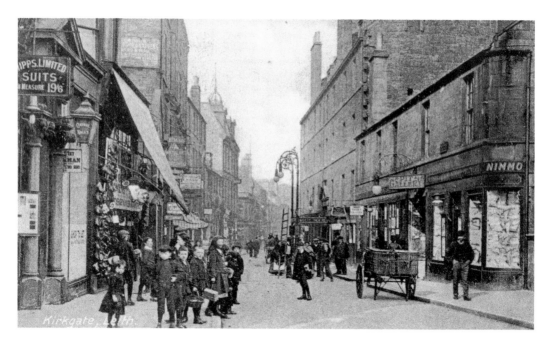

The Kirkgate

The Kirkgate was the pulsating heart of Leith. It was one of the oldest and principal streets of Leith until the 1960s, when the entire area was replaced with modern housing developments, a new shopping centre and a community centre. All that remains of the historic location is Trinity House and South Leith Parish church. The ornamental street lamps indicate the entrance to the new Gaiety Theatre, which was opened in 1889 as the Princess Theatre, but changed its name ten years later to the New Gaiety Theatre and finally closed in 1956.

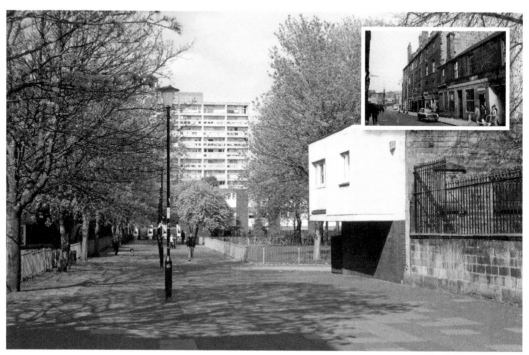

The Kirkgate

Some of the familiar shops at the top of the Kirkgate from the 1950s and '60s that contrast with the modern frontages of today. A group of Teddy Boys congregate outside of the Albert Fish Restaurant next to the popular Record Mart.

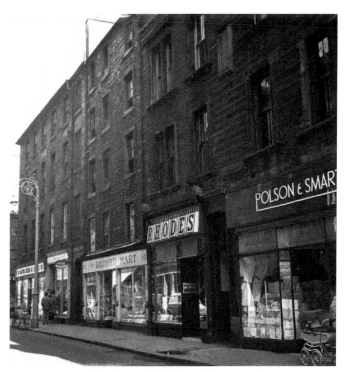

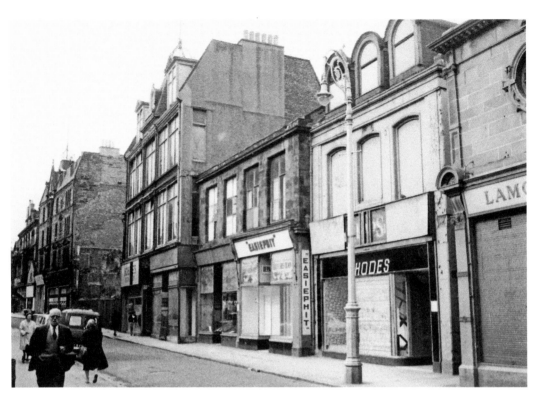

The Kirkgate

Looking up the Kirkgate towards the Foot of Leith Walk from the corner of Coatfield Lane.

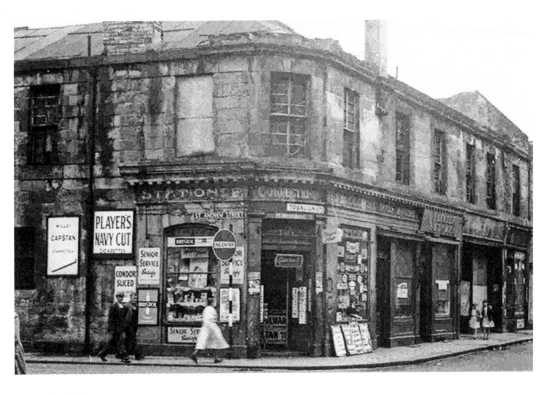

The Kirkgate

An array of cigarette adverts on McLaggan's newsagent at the corner of St Andrew Street and the Kirkgate. This newsagent was a well-known stopping off point for papers and fags.

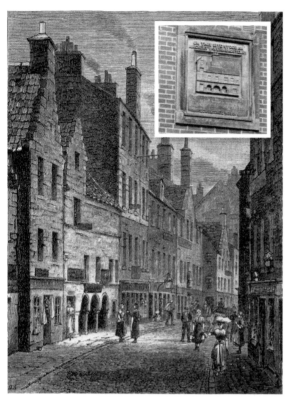

The Kirkgate

Cant's Ordinary, with its three arch frontage, was said to have been visited by Mary Queen of Scots, Oliver Cromwell, Charles II and many other notable people, until it was demolished in 1888. The name Cant's Ordinary is said to derive from the communal method of dining in such taverns. The building that replaced Cant's Ordinary incorporated a commemorative carved stone, which was moved to its current location following the 1960s redevelopment of the Kirkgate.

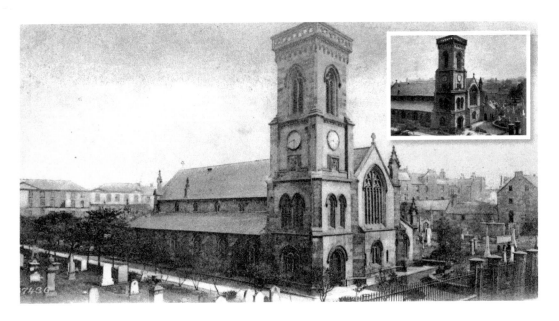

South Leith Parish Church

The present South Leith Parish church in the Kirkgate is known to most Leithers. It dates from 1848 and was built on the site of the fifteenth-century Kirk of Our Lady. In 1645, the church provided relief to the victims of the plague in Leith, when over 2,700 people fell victim to the disease. The colours of the 7th Company of the Scots Guards are kept at the church in memory of the Gretna Rail Disaster. The graveyard is the burial place of John Pew, the inspiration for Blind Pew in Robert Louis Stevenson's novel *Treasure Island*; Adam Whyte, Leith's first Provost; and Hugo Arnot, the Leith historian.

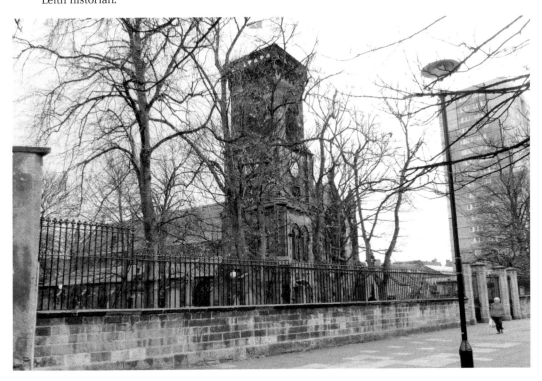

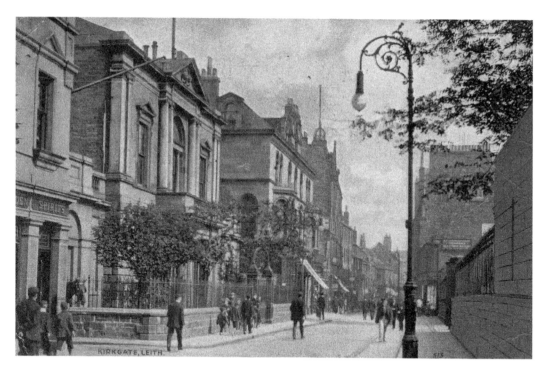

Trinity House

Trinity House was built on the Kirkgate between 1816 and 1818, as the headquarters of the Fraternity of Masters and Mariners, a charitable foundation for seamen. The current building incorporated the basement and vaults of the former Trinity House and Mariners' Hospital of 1555. The Fraternity's original purpose was benevolent, but later it provided pilots for the navigation of the Forth, and was responsible for installing the first oil lamp guide light on May Island.

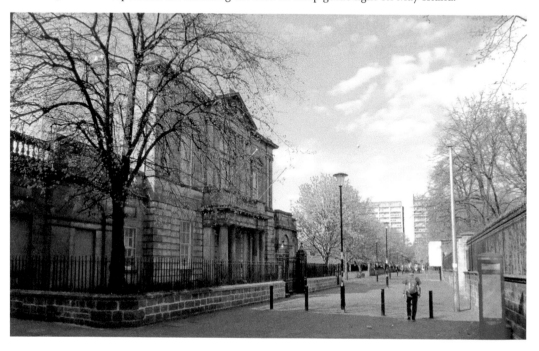

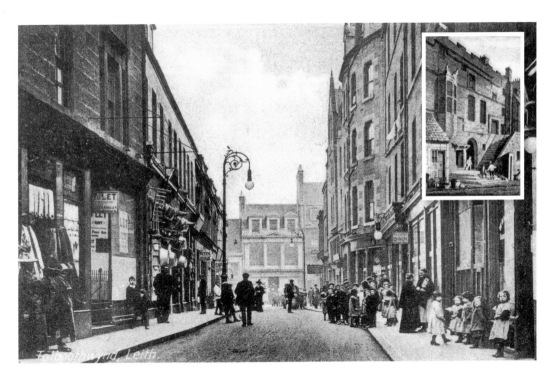

Tolbooth Wynd

Tolbooth Wynd was one of the oldest streets in Leith and takes its name from the long-gone original Leith Tolbooth, which dated from 1565. Tolbooth Wynd, like the Kirkgate, was noted for its bustling character and wide range of shops. Tolbooth Wynd disappeared with the Kirkgate in the comprehensive redevelopment of the sixties.

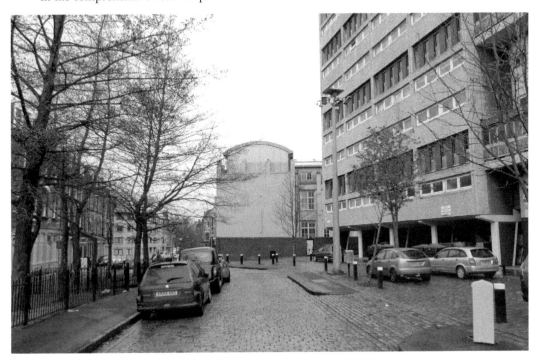

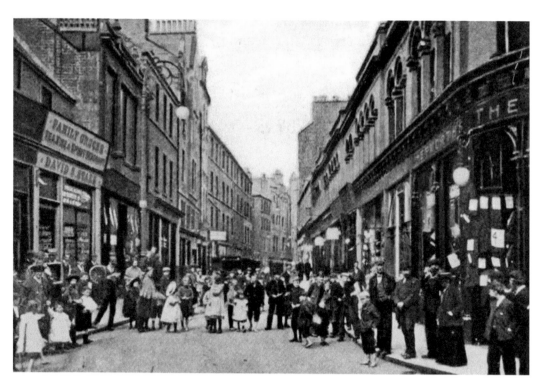

Tolbooth Wynd

Looking towards the Shore on Tolbooth Wynd. A large group of Leithers gather to get in the photograph.

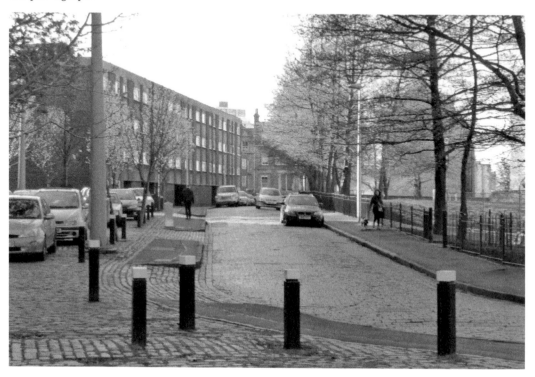

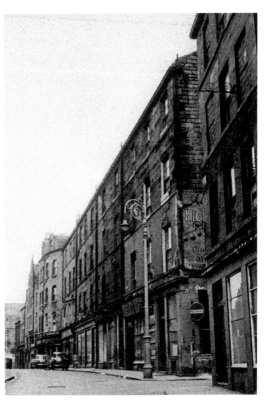

Tolbooth Wynd
The historic stone tenements of Tolbooth Wynd were replaced by the multi-storey Linksview House and other new housing in the 1960s.

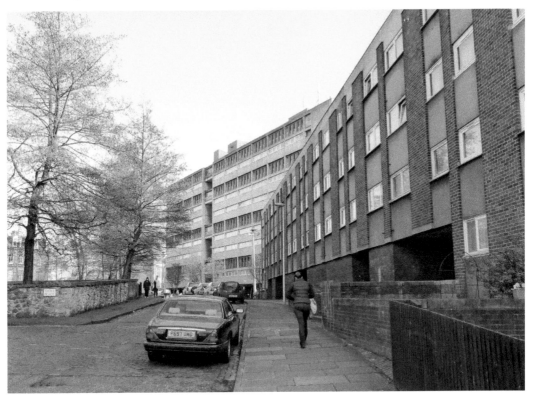

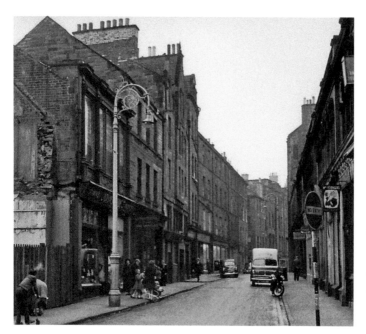

Tolbooth Wynd
Tolbooth Wynd from the junction with the Kirkgate. The demolished building on the left of the older image is a portent of things to come for this part of Leith.

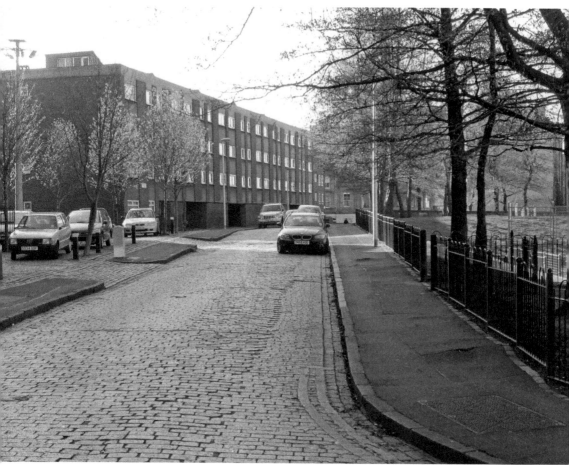

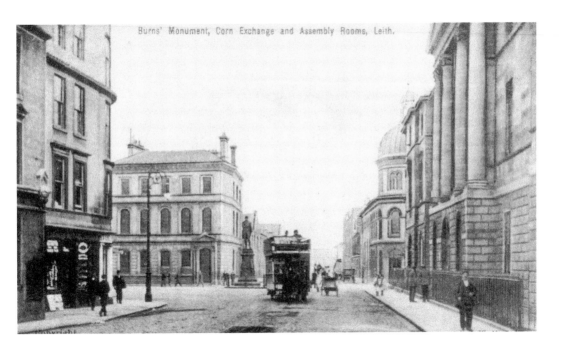

Assembly Rooms, Constitution Street

The Assembly Rooms opened in 1783 as a centre for social events for more affluent Leithers. The adjoining exchange buildings were added in 1809 at a cost of £16,000, and were the commercial base of the port of Leith. The domed Corn Exchange was, at one time, the hub of the trading of grain in Scotland. The building dates to 1862 and includes a distinctive frieze, which shows cherubs involved in a range of activities associated with the production and marketing of grain. The Corn Exchange was so spacious that it was often used as a drill hall by the entire battallion of Leith Rifle Volunteers in the nineteenth century.

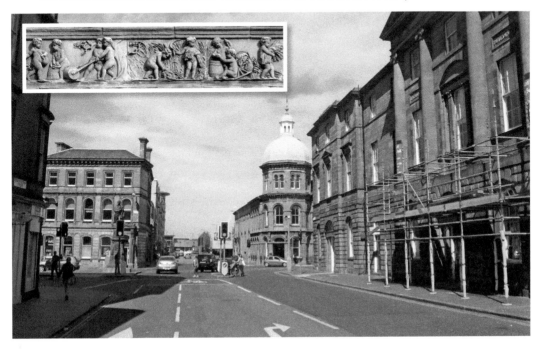

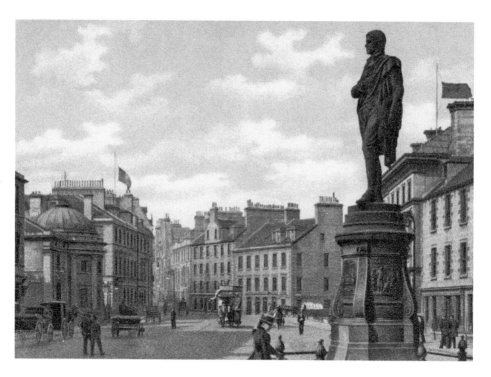

Bernard Street

Bernard Street is the civic heart of Leith and an outstanding urban space. It follows what would have been the original shoreline. The street takes its name from Bernard Lindsay, who, in 1604, held the title Groom of the Bedchamber to James VI.

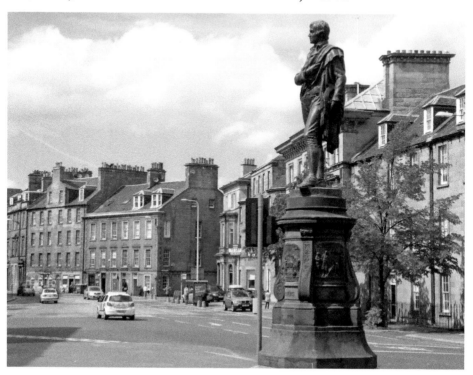

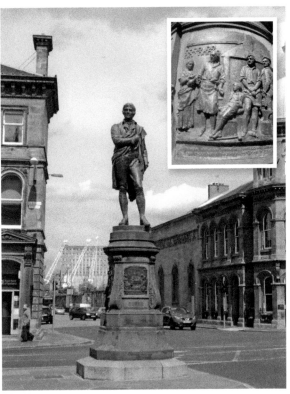

Burns' Monument, Bernard Street
It was reported that a 'holiday mood' prevailed as thousands gathered on Bernard Street on 15 October 1898 for the unveiling of a new bronze statue of Robert Burns. The pedestal includes bronze panels depicting poems by Burns. The statue is by the eminent sculptor D. W. Stephenson, who, in 1900, had sculpted a bust of William Ewart Gladstone. The figure of the blacksmith on the plaque, depicting the poem Scotch Drink, bears a striking resemblance to Gladstone, who was Leith's Member of Parliament for a period. In 1961, the statue was moved 18 feet to the west to ease the flow of traffic at the junction. In 2004, the statue was moved again, this time just over a yard during road improvements.

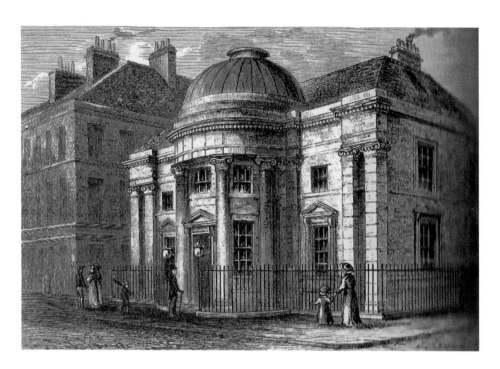

Bank of Leith, Bernard Street

The centrepiece of Bernard Street is this elegant classical building, constructed in 1806 as the main office of the Leith Banking Co., which was first established in 1792 by eighteen Leith merchants. The bank prospered in the early nineteenth century and had branches in other parts of the country. Sir Walter Scott is believed to have been an account holder. In 1842, due to debts, it was merged with another bank to become the Edinburgh and Leith Banking Co. This was later merged into the Clydesdale Bank.

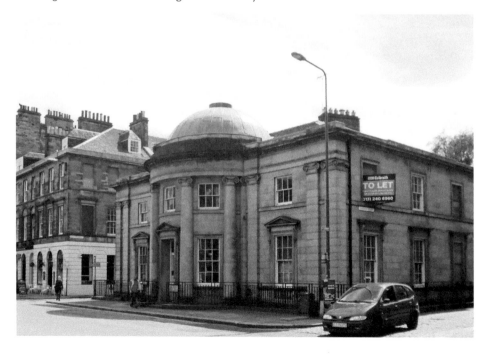

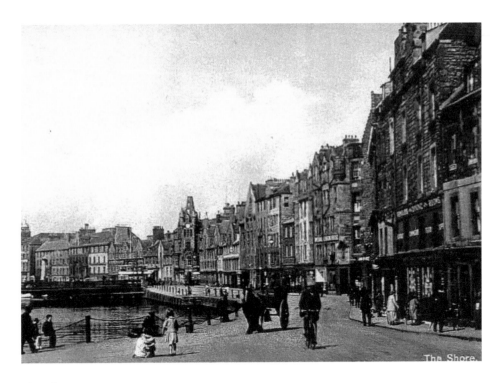

The Shore

The Shore is not on the seashore, but forms a curving street that leads into the entrance to the docks. It is the most historically important part of Leith. Mary, Queen of Scots, made landfall from France at The Shore in 1561, and the arrival of King George IV on his state visit is marked by a plaque on the quayside.

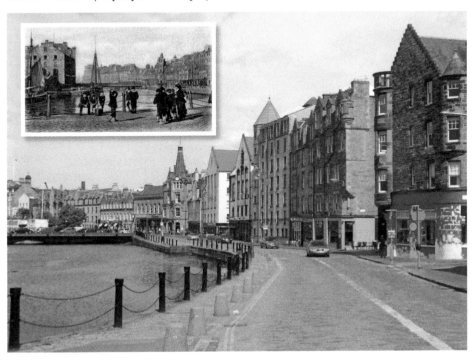

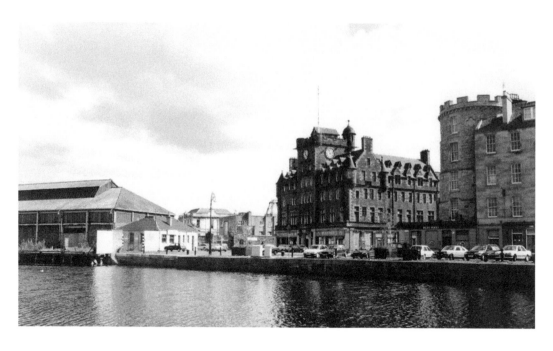

The Shore

The Shore area in 1988 at the start of its regeneration, which attracted a broad range of new upmarket bars, restaurants and new housing. (*1988 photograph courtesy of Jennifer Wells*)

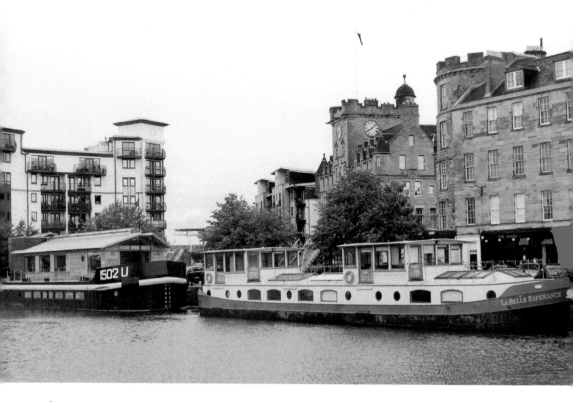

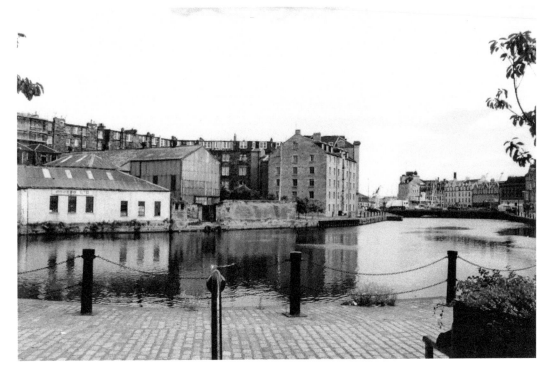

No. 23 Ronaldson's Wharf
The contrasting use of Ronaldson's Wharf – changed from commercial use in the 1980s to its current residential use. (*1980s photograph courtesy of Jennifer Wells*)

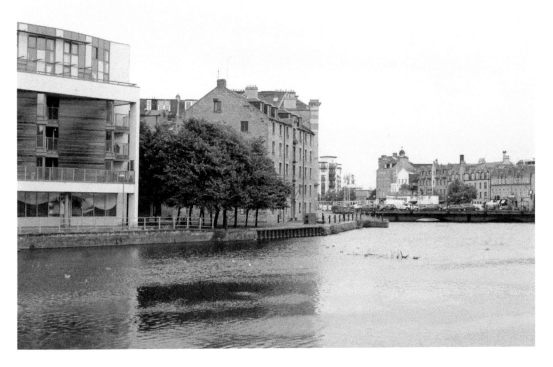

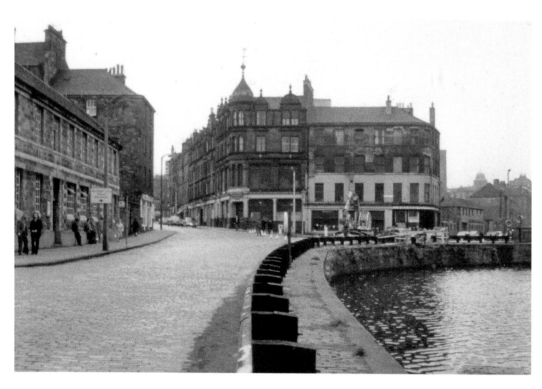

The Shore
The recent addition of a modern block of flats makes a dramatic impact on the upper Shore.

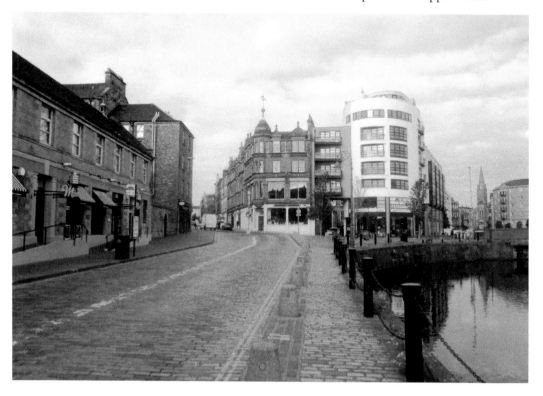

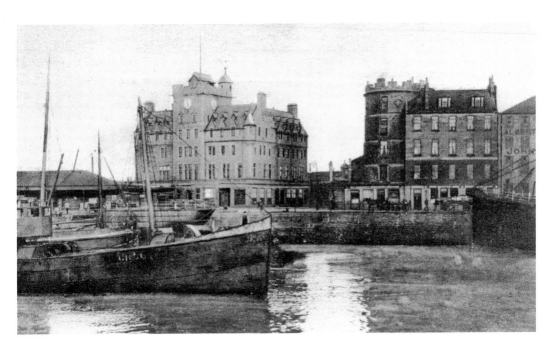

The Shore, the Signal Tower and Sailors' Home

The Signal Tower is an important Leith landmark at the corner of the Shore and Tower Street. It dates from the seventeenth century and was built originally as a windmill. In 1805, the sails were removed and battlements added. It was used as a signal tower from which flags were displayed to let ships entering the harbour know the depth of water at the harbour bar. The much loved Sailors' Home was opened on 29 January 1885. It provided a dry, warm bed for the sailors from around the globe who found themselves in the port. The building has a number of carvings, including Britannia and Nelson, as well as the arms of Leith and Edinburgh. It was converted into the Malmaison Hotel in 1994.

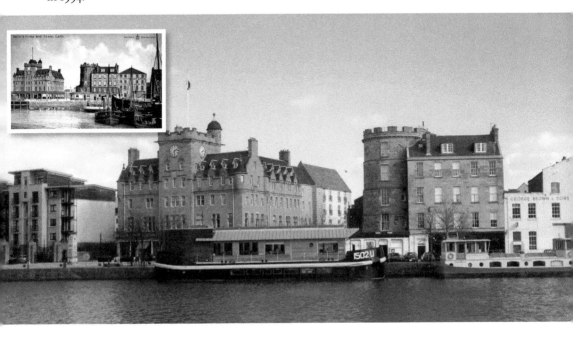

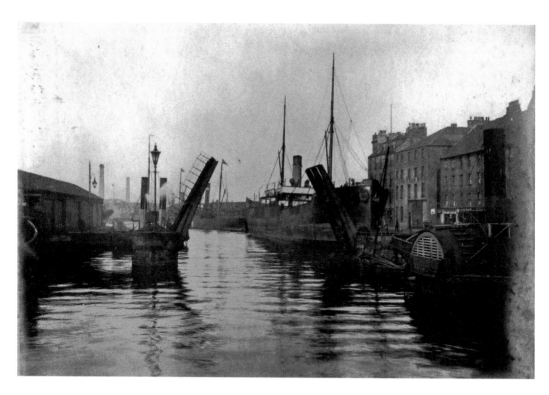

The Shore, the North British Railway Drawbridge
The North British Railway Drawbridge was a crossing from the rear of the Custom House to the Shore, and was removed in March 1910. (*Above photograph courtesy of Archie Foley*)

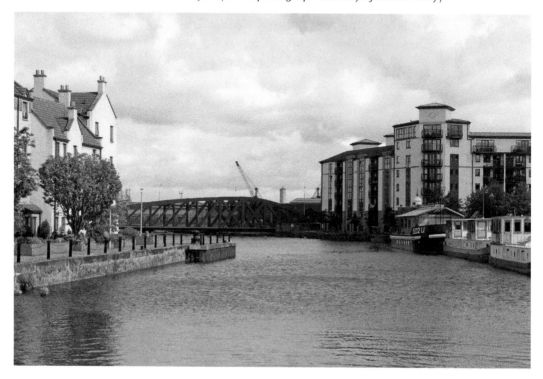

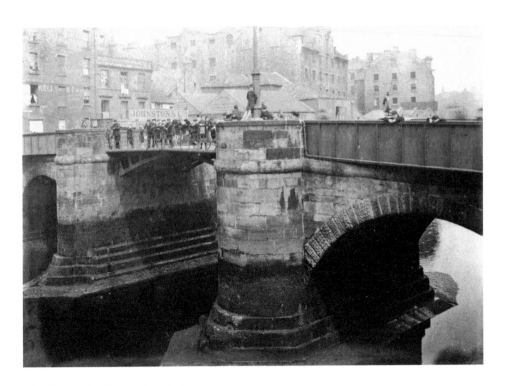

The Shore, the Upper Drawbridge

This bridge replaced the nearby fifteenth-century Brig o' Leith crossing in 1787. It was known as the Upper Drawbridge and it enabled ships to berth further upstream. The tenements in the background have been replaced by a recent development of flats. (*Above photograph courtesy of Archie Foley*)

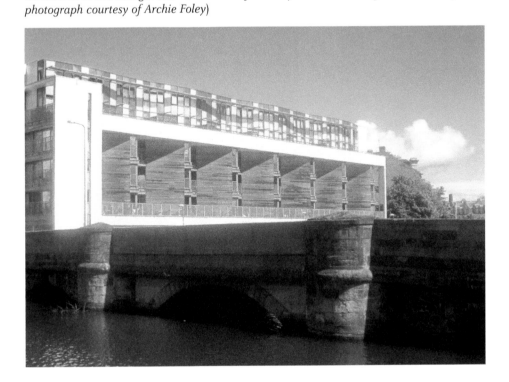

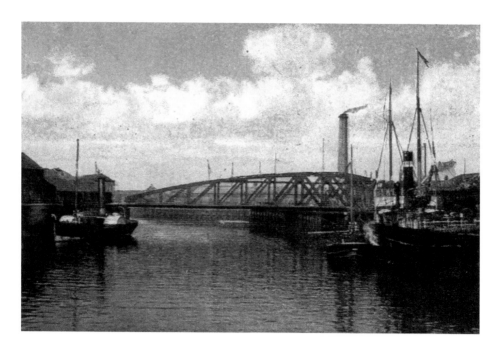

The Victoria Swing Bridge

The Victoria Swing Bridge was opened in 1874 to link the Victoria Dock with the Albert and Edinburgh Docks. It weighs 620 tons, its wrought-iron girders are 212 ft long and the roadway width is 24 ft. It was the largest swing bridge in the United Kingdom until the opening of Kincardine Bridge in 1937. The bridge was hydraulically operated to allow ships to pass up the Water of Leith. The bridge no longer swings and the road and rail tracks have been removed. A new, fixed road bridge has been built immediately downstream to link motor traffic through to the Ocean Terminal shopping centre. The water of Leith was tidal until 1969, when the sealing dam and lock gates were completed, ensuring a permanent high tide.

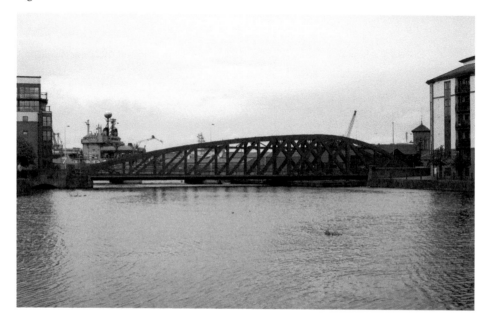

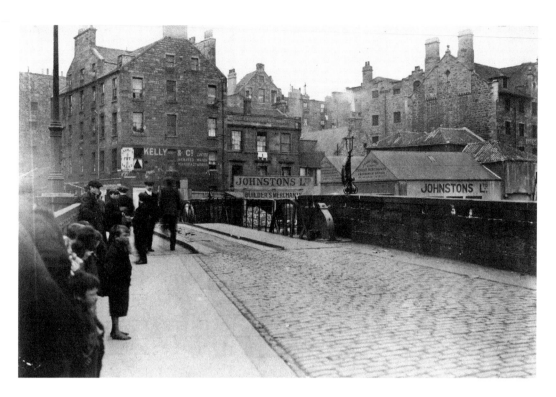

The Shore, the Upper Drawbridge
A group of Leithers on the Upper Drawbridge in 1909 in the older image. (*Above photograph courtesy of Archie Foley*)

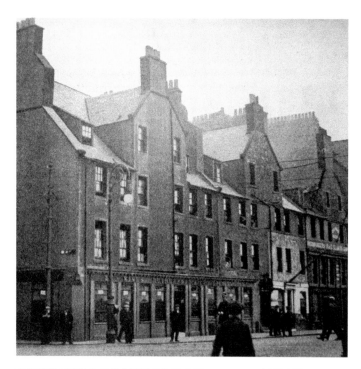

The King's Wark,
Bernard Street and
the Shore

The King's Wark has
characteristic Dutch gables
and scrolled skewputts, in
typical early
eighteenth-century
fashion. It stands on
older foundations,
which were part of a
much larger complex
of buildings, begun by
James I in 1434 to serve
as a royal residence with
a storehouse, armoury,
chapel and tennis court.
The pub, which occupied
the building, had a
notorious reputation, and
was known locally as 'the
Jungle'. It is
now a much more
salubrious establishment.

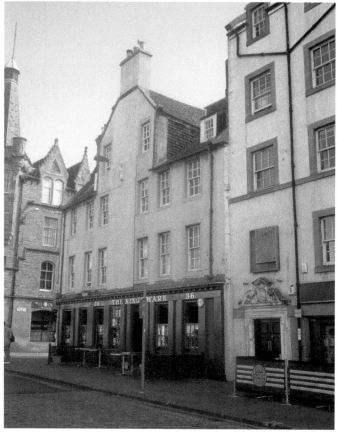

Andro Lamb's House, Water's Close
Lamb's House in Water's Close off
Burgess Street is one of the largest
and most architecturally impressive
seventeenth-century merchants' houses
in Scotland. The house takes its name
from Andrew Lamb, the first recorded
owner. Legend has it that Mary, Queen
of Scots rested for an hour in the house
when she arrived in Leith on 19 August
1561; but the house was not standing at
the time. In the early twentieth century,
the building was subdivided into a
number of flats and, by the 1930s, was
in a derelict condition. The Marquess
of Bute stepped in to buy the building
for £200 in 1938. It was restored by
the architect Robert Hurd and, in 1958,
the building was gifted to the National
Trust for Scotland. It was then leased to
the Edinburgh and Leith Old People's
Welfare Council and used as a day
centre for the elderly. It has now been
expertly restored as a family home.

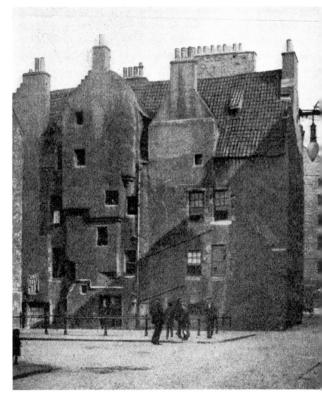

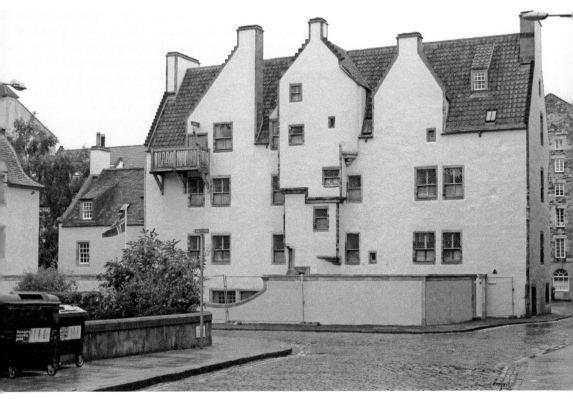

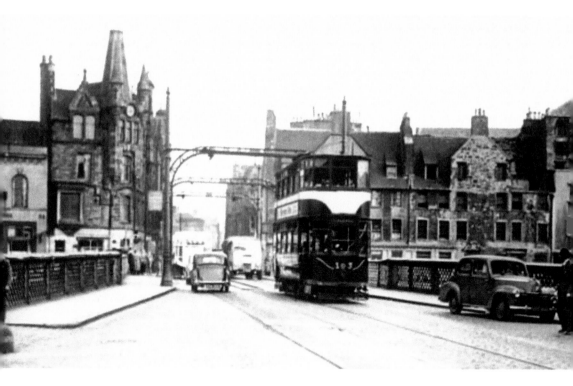

Bernard Street Bridge
The large hoop-like structures carried the electric tram cables so that the bridge could still open for ships. The swing bridge was replaced by a fixed structure in the 1960s.

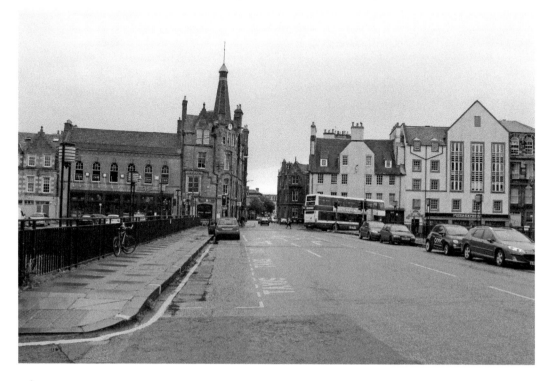

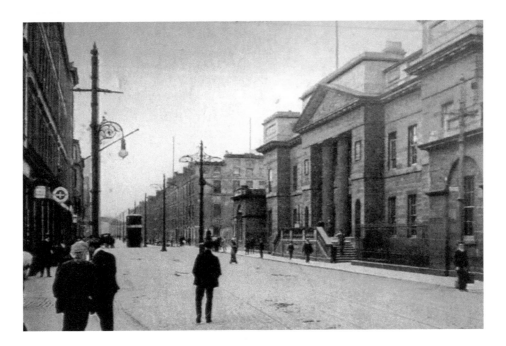

Customs House, Commercial Street

The Custom House in Commercial Street was designed by Robert Reid and opened for the business of collecting duty on goods imported through Leith in 1812. Its Greek Doric Revival style is typical of the way Leith buildings of the period tended to reflect, on a smaller scale, those of the neo-classical New Town of Edinburgh. It is located on the site of the old ballast quay, and was a replacement for the old Custom House in Tolbooth Wynd. The pediment above the entrance displays the royal coat of arms of George III. In recent years, the building was used by the National Museums Scotland for storage. It is hoped that the building will be transformed into a museum for Leith.

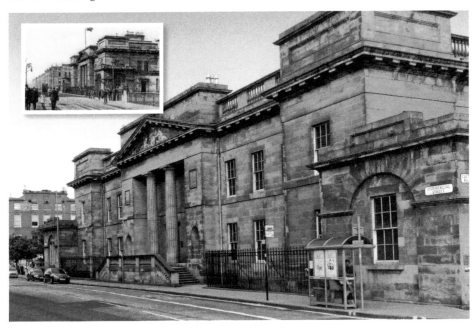

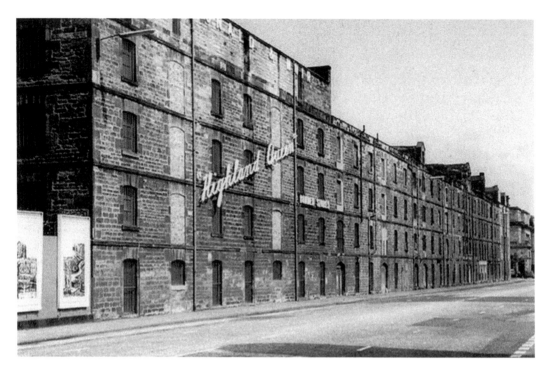

Highland Queen, Commercial Street

This is the old Highland Queen (MacDonald & Muir) whisky bonds, which have been converted to upmarket flats, restaurants and shops. Leith has a long association with whisky. Scores of bonded warehouses in Leith matured 90 per cent of all the whisky made in Scotland, and the Vat 69 blend was distilled locally by Sandersons. (*Above photograph courtesy of Steven Saunders*)

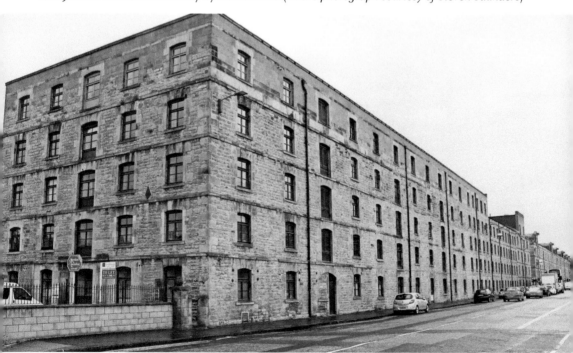

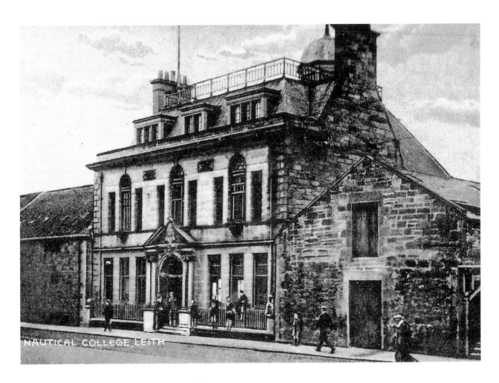

NAUTICAL COLLEGE, LEITH

Leith Nautical College, Commercial Street

Leith Nautical College was originally founded as Leith Navigation School in 1855, at the Mariner's church in Commercial Street. In 1903, the school moved to purpose-built premises in Commercial Street and changed its name to Leith Nautical College. The Commercial Street college closed in 1977 and moved to new premises in Milton Road. Many Leith seamen will have fond memories of their training days at the college.

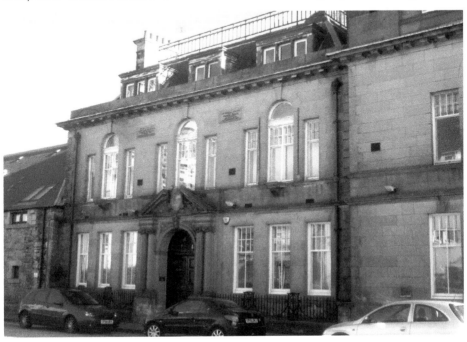

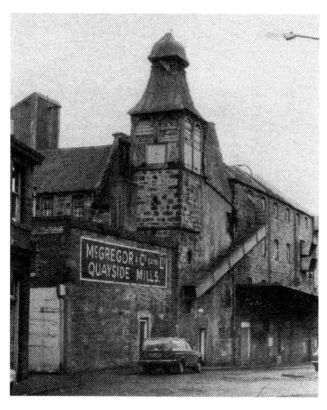

St Ninian's Chapel, Quayside Street

In 1493, Robert Bellenden, the Abbot of Holyrood, founded the chapel dedicated to St Ninian on the bank of the Water of Leith. It is the oldest building in Leith. The building fell into ruin after the Reformation, was restored in 1595 and became the church of a new parish of North Leith in 1606. It was rebuilt and extended in the late seventeenth century, when the distinctive steeple was added. In 1816, the congregation moved to a new church in Madeira Street, which was then in open countryside. In 1825, St Ninian's was converted for commercial purposes, as a granary and a mill. It was restored as offices by the Cockburn Association in 1997.

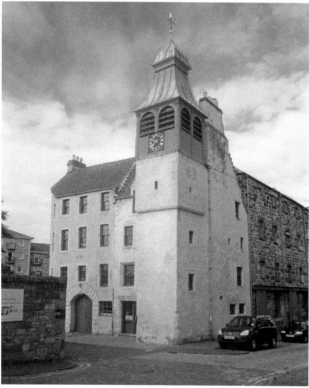

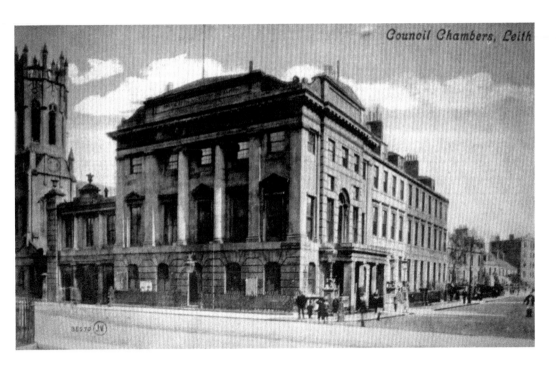

Leith Police Station, Constitution Street/Queen Charlotte Street (former Municipal Buildings and Council Chambers)

In 1833, when Leith won its independence from Edinburgh's control and became a separate burgh, the new council took over the existing court building that had been built five years before. The building was an important symbol of Leith's independence. Leith's architecture of the time reflected the Port's heightened aspirations, and a number of substantial buildings appropriate to its new status were built throughout the nineteenth century The Leith Police office has been based in the building throughout its history.

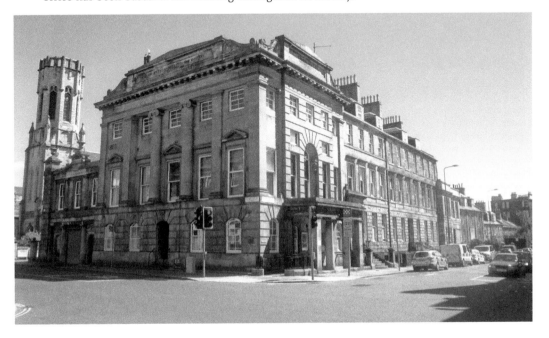

41

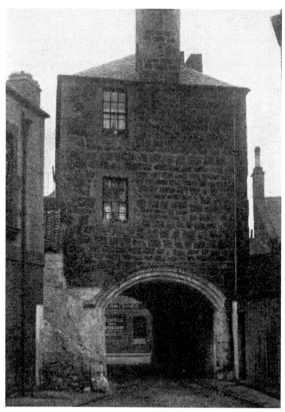

Leith Citadel, Dock Street

This arch in Dock Street was the main entrance to the seventeenth-century Leith Citadel. In 1650, Cromwell's army occupied Leith after their victory at the Battle of Dunbar. In 1656, a large fort – Leith Citadel – and barracks were built. The Citadel, 'passing fair and sumptuous', was erected on the site of the Chapel of St Nicholas at the foot of Dock Street. The house over the archway, according to tradition, was the meeting place of the officers and men of Cromwell's Ironsides in Leith.

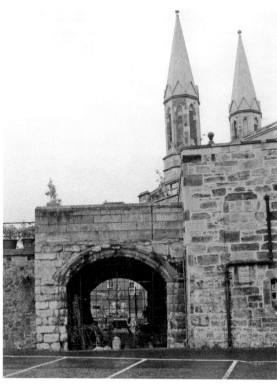

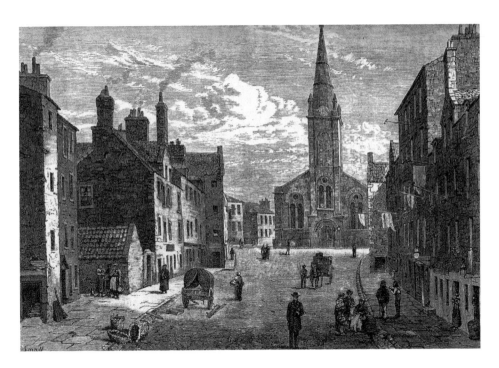

Former St Thomas's Church, Sheriff Brae

St Thomas's church dates from 1840–43, and was founded by Sir John Gladstone, the son of Thomas Gladstone, a Leith-born flour merchant, and father of British Prime Minister William Ewart Gladstone. Sir John made a fortune in the corn trade and was inspired to build the church in memory of his wife, who passed away in 1835. The development originally included a manse, school and hospital. In April 1916, the manse was destroyed during a Zeppelin raid. The church survived the raid intact and continued in use until May 1975. In 1976, the building found new life as the Guru Nanak Gurdwara Sikh Temple.

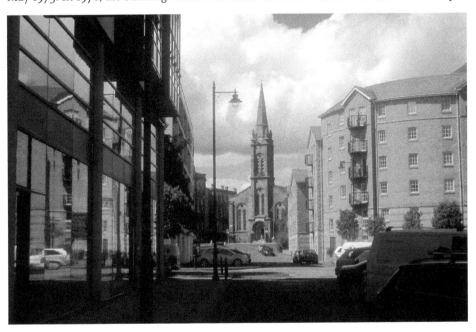

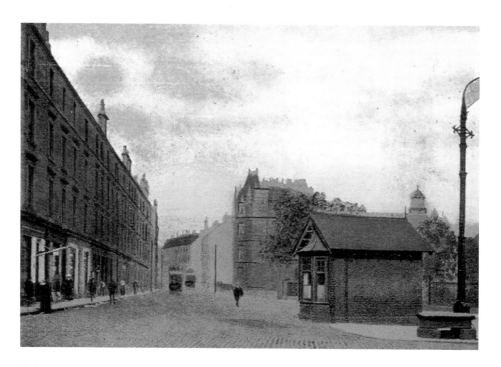

Duke Street

Duke Street was named after the Duke of Dalkeith in 1812. He was an enthusiastic golfer and rented a house in the area to be close to the course at Leith Links. Incredibly, only the immediate right side of this view has changed over the years. The tenements of Duke Street remain today, having survived the sixties' redevelopment. This view is taken from the roundabout at the foot of Easter Road. Duncan Place is down to the right, behind that small brick building, which was a tram/bus turnaround and stop-off place for crew to have a tea and loo break.

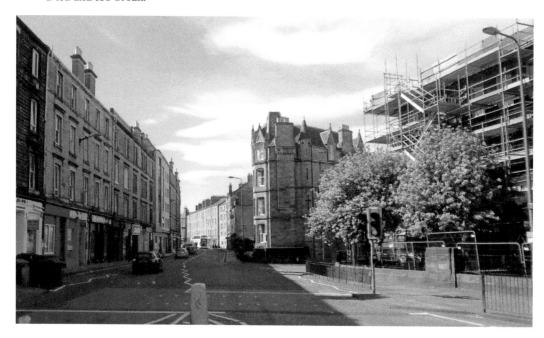

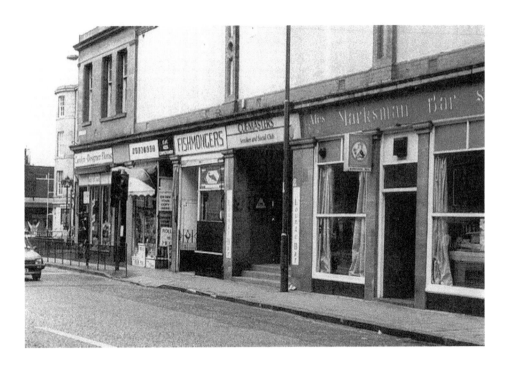

Duke Street Shops

The Duke Street entrance to the Palace Cinema is seen here in 1992 when it had become Cuemasters Snooker Hall. The building was originally the Palace Cinema, which opened in 1913 and seated around 2,000. It closed in 1966, after which time it became a bingo hall. Although now part of a large pub chain, remnants of the original cinema can be seen in the upper part of the building. The confectioners and the fishmongers were well established small Leith businesses. (*Above photograph courtesy of Steven Saunders*)

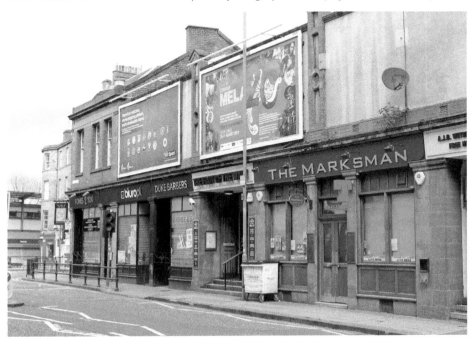

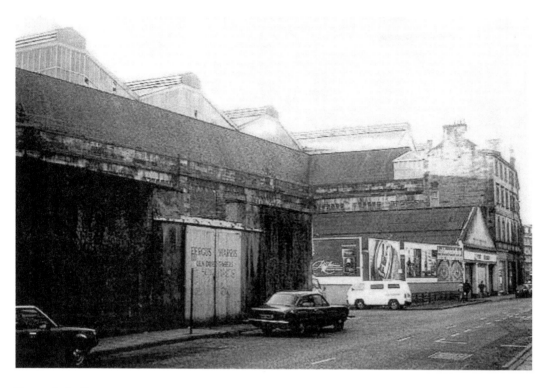

Tesco, Duke Street
The Tesco supermarket on Duke Street is located on the site of the Leith Central Station. (*'Then'*
photograph courtesy of Old Leither)

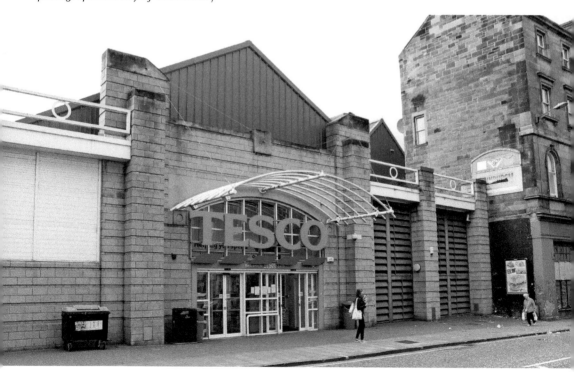

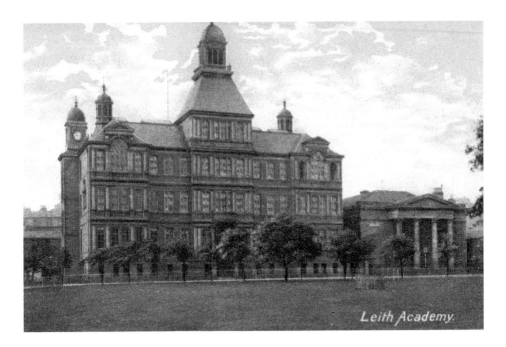

Leith Academy.

Leith Academy, St Andrew Place

This imposing red, sandstone building on St Andrew Place overlooking Leith Links was the home of Leith Academy for 125 years. Leith Academy has the longest history of any school in Scotland. It is believed to have been founded in 1560, associated with South Leith Parish church. Its first recorded premises were Trinity House in 1636, where it was based until 1710. After a disagreement about the £3 a year rent, the school moved to a building that stood on South Leith Parish churchyard. In 1806, the school moved to the site of St Andrew Place, and this building dates from 1896. The latest Leith Academy on Academy Park was opened in May 1991. The St Andrew Place building is now used by Leith Primary School.

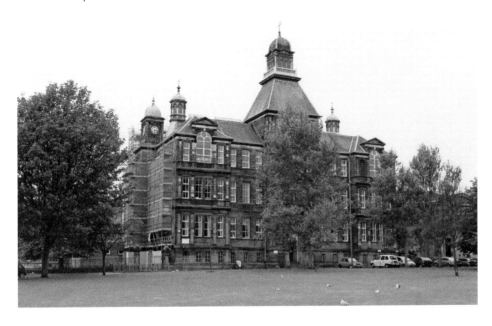

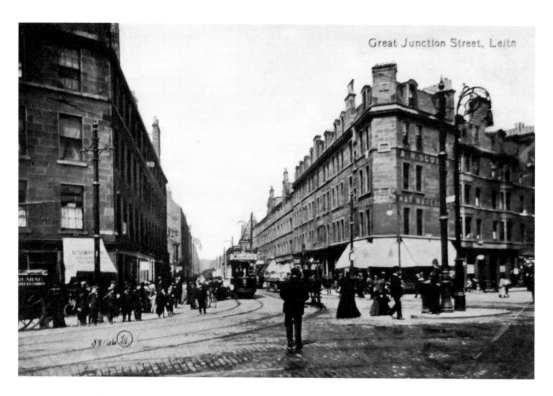

Great Junction Street

Great Junction Street was developed from around 1800 as a link between the Foot of Leith Walk and new docks at North Leith. The idea was to bypass the congested streets of historic old Leith. It followed the line of the fortifications of 1548, which had left a strip of open ground.

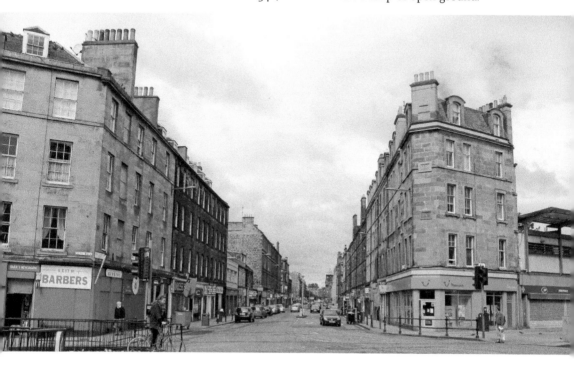

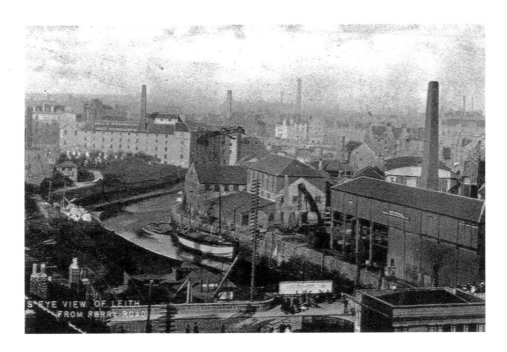

Bird's Eye View of Leith from Ferry Road

A much changed view of Leith from Junction Bridge. The older image has been taken from the upper floors of a tenement on Ferry Road. There are no tram wires on the bridge, which dates the photo to pre-1905. The photo shows the roof of the entrance to Junction Road Station at the bottom right. The busy upper deck of a horse-drawn tramcar crossing Junction Bridge can also just be seen. The number of factory chimneys reflects the industrial nature of Leith at the time. Hawthorn's shipbuilding and engineering yard, with a moored ship outside, is to the right of the Water of Leith. On the opposite side of the river it is just possible to see the railway line, the coal sidings near the bridge and North Leith Graveyard.

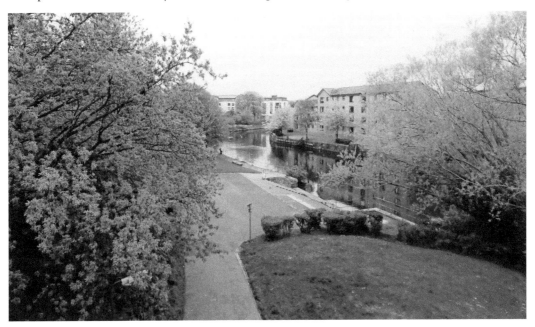

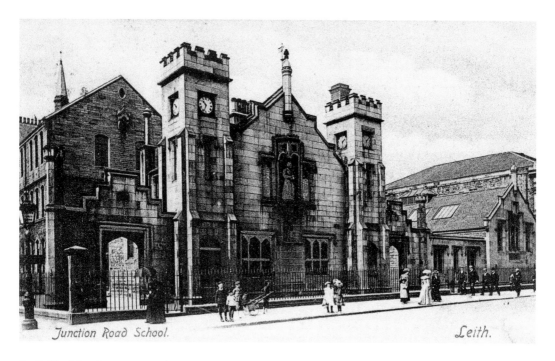

Junction Road School. Leith.

Dr Bell's School, Great Junction Street

Dr Bell's School on Great Junction Street was built in 1839. It was one of two schools founded by Dr Bell, the other one being on South Fort Street. Dr Bell's school had accommodation for 900 pupils. Dr Andrew Bell (1753–1832) was a minister and an important educationalist who was born in St Andrews. He developed an innovative form of education – the Madras System – during his time in India as a school superintendent. It was based on more advanced pupils helping younger pupils in the school.

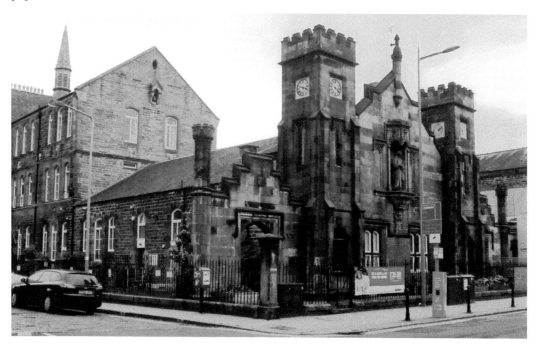

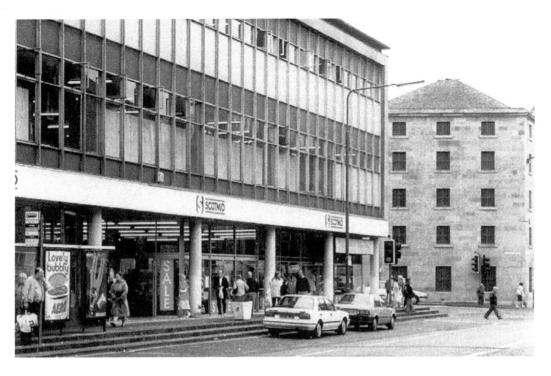

Telectra House, Great Junction Street

The ultra-modern Telectra House appeared on the corner of Great Junction Street and Cables
Wynd in 1963, as the flagship store of Leith Provident Co-operative Society. It stood on the site
of the earlier St James School. It was demolished in 2003, the site was then redeveloped for flats.
(*Above photograph courtesy of Steven Saunders*)

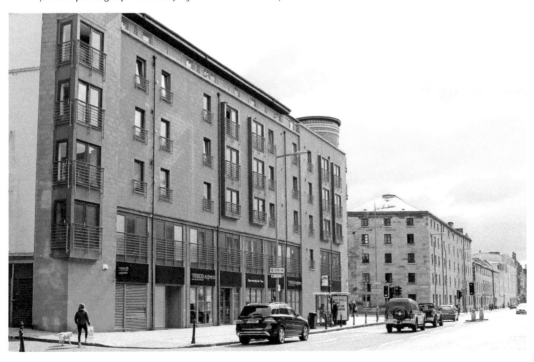

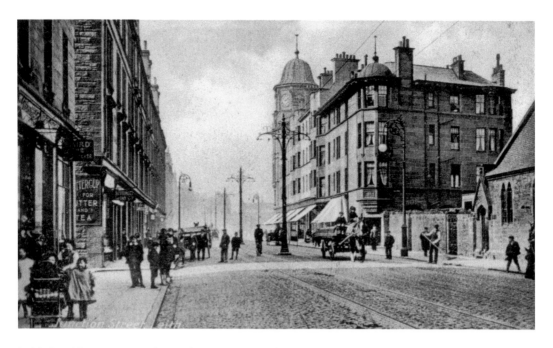

Leith Provident Co-operative Society, Great Junction Street

The turreted building was built in 1911 as a department store for the Leith Provident Co-operative Society. Co-operative societies allowed customers to obtain membership, effectively becoming stakeholders in the company, meaning that the business could be tailored to suit the economic interests of the consumer rather than the store owners. Each customer was assigned their own specific five or six digit dividend number, or 'divi', which would see them receive a payment at the end of the financial year based upon how much they had spent. The Leith Provident was taken over by the Edinburgh-based St Cuthbert's Co-operative Society in 1966.

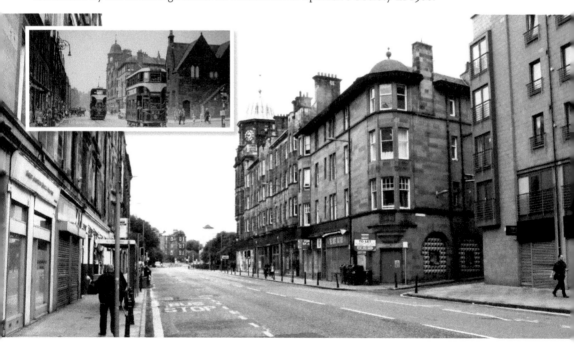

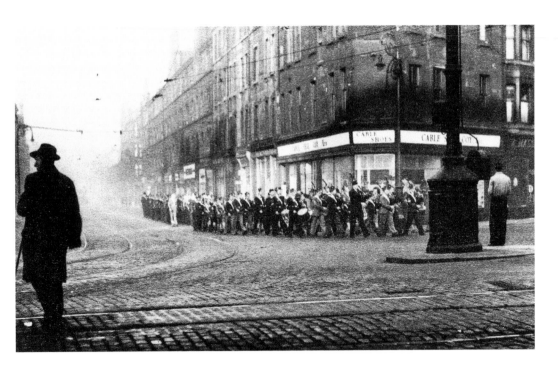

Boys' Brigade Parade, Great Junction Street
Must be a Sunday morning! An atmospheric photograph of the 3rd Leith BB Company on parade, heading to the Foot of Leith Walk along a quiet Great Junction Street. The company was based at Claremont Kirk, now Leith St Andrew's, on the corner of Lochend and Easter Road. This company parade is on the occasion of its Golden Jubilee in 1949. (*Above photograph courtesy of Joanne Baird and Third Leith BB Archives*)

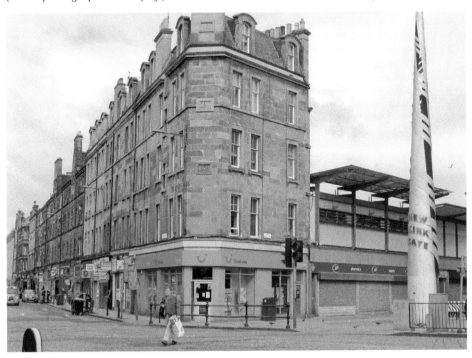

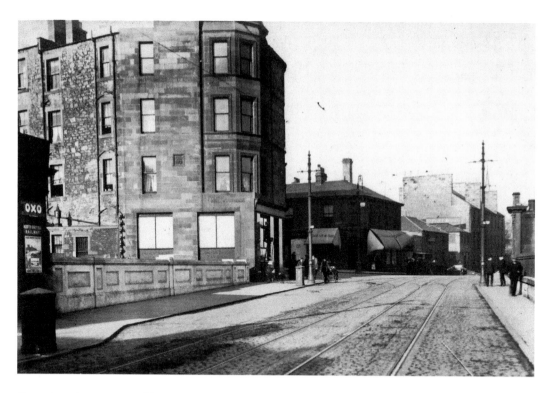

Great Junction Street Bridge

A view across the bridge in 1909. In the distance are the Corner Rooms on the junction with Ferry Road. There is a glimpse of the station building on the left edge with its 'Oxo' advert. (*Above photograph courtesy of Archie Foley*)

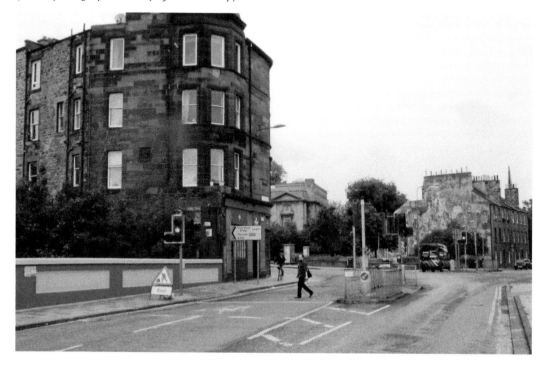

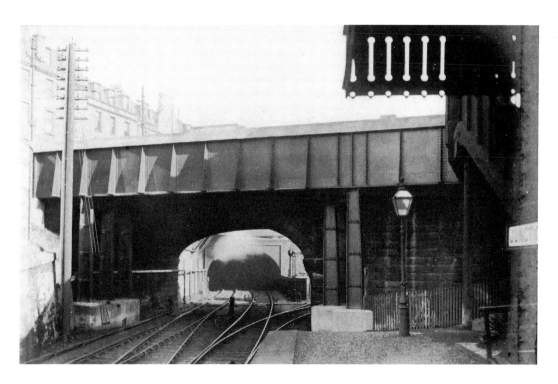

Junction Bridge Station

Junction Bridge station is seen here in 1909 huddled beneath Great Junction Street Bridge. The yawning tunnel ahead eventually led to the Citadel station on Commercial Street. It was the branch line for the Edinburgh, Leith and Newhaven Railway, carrying freight and passengers to the Port. The staircase up to Great Junction Street can be seen on the right edge of the image. (*Above photograph courtesy of Archie Foley*)

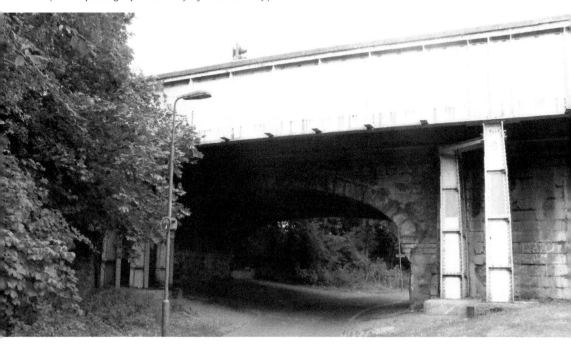

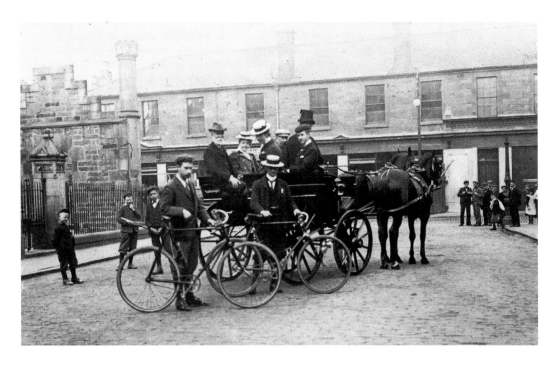

Junction Place

A gathering of well-dressed Leithers, with bikes and a carriage, prepared to set off for a day trip. Meanwhile, other locals regard the scene with some interest, and possibly suspicion, on the corner with Great Junction Street. There is a stark contrast between the available transport in the two images.

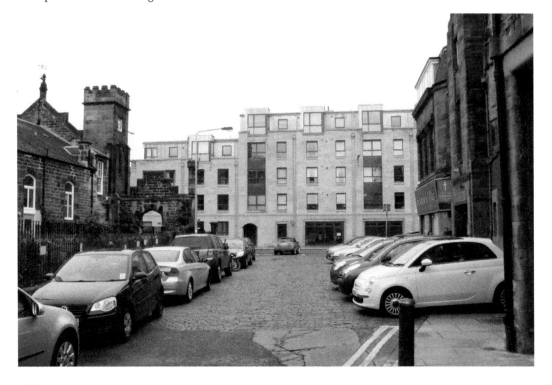

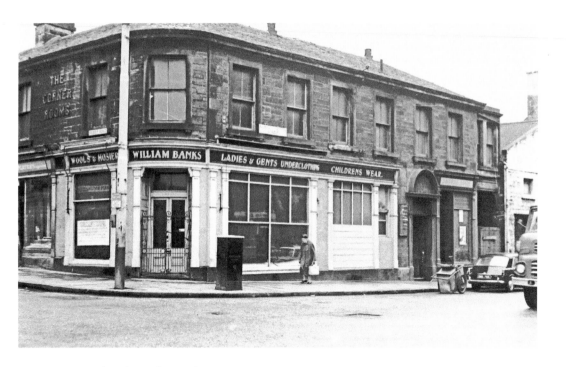

Ferry Road and North Junction Street

These are the buildings that sat on the corner of Ferry Road and North Junction Street next to Leith Library. The upper floor held the Corner Rooms, which hosted all sorts of activities from dance classes to pipe band practice. Today, this is an open-air seating area, with the Leith Mural on the gable wall. The doorway next to the 'children's wear' sign was the entrance to the Corner Rooms.

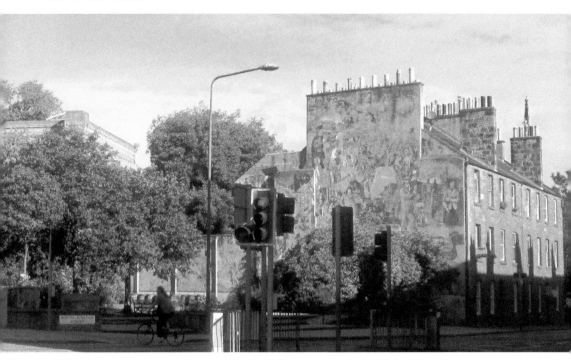

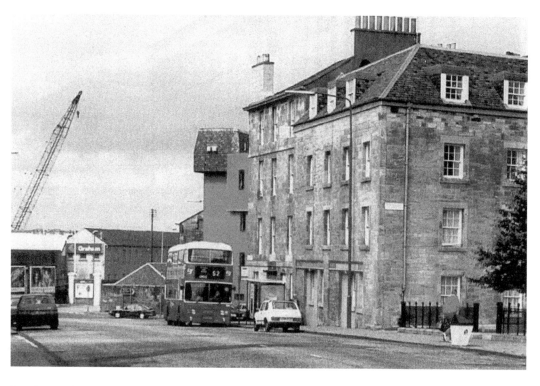

North Junction Street

North Junction Street showing the transformation of the harbour area in the background, where more recent housing has replaced the hoists and warehouses of the docks. (*Above photograph courtesy of Steven Saunders*)

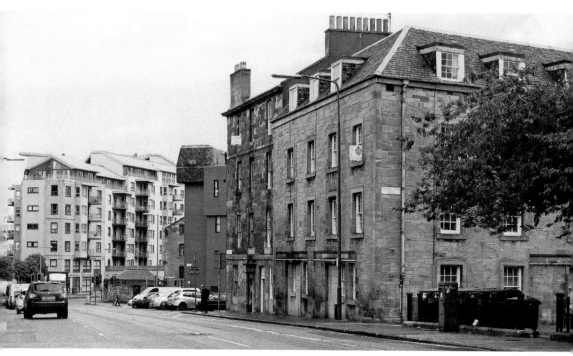

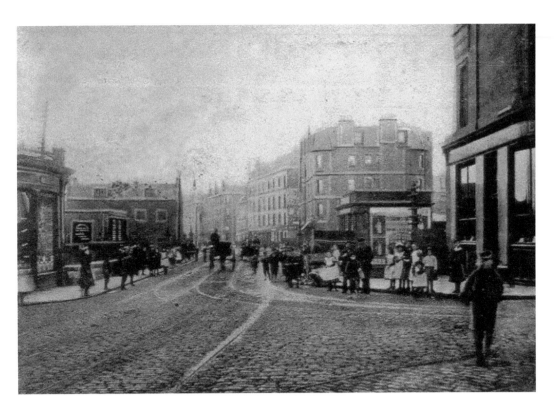

Great Junction Street Bridge

A fine view over the Great Junction Street Bridge in 1904. The station building can be seen on the right-hand side (behind the hoardings), where passengers descended to the platforms below. This line has been closed for many years, and the absence of the buildings leave the bridge looking somewhat barren.

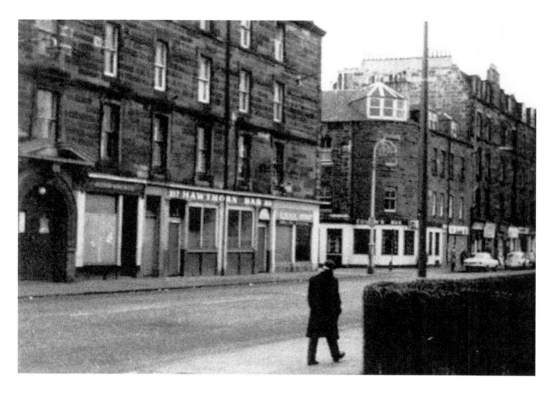

Taylor Gardens

Two of Leith's best-known 'watering holes' – the Hawthorn Bar and Cousin's Bar – were located opposite Taylor Gardens. The tenements were demolished in the 1960s and were replaced by the Quilt's housing area. (*Above photograph courtesy of John Darcy, Old Leithers*)

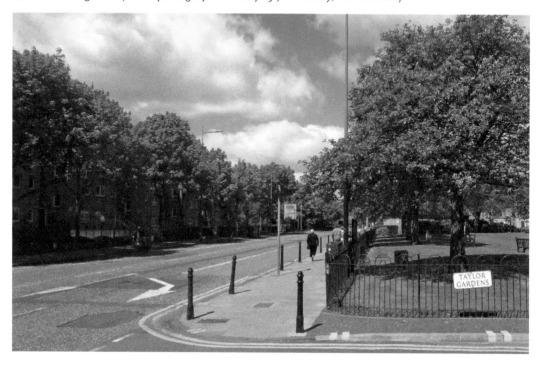

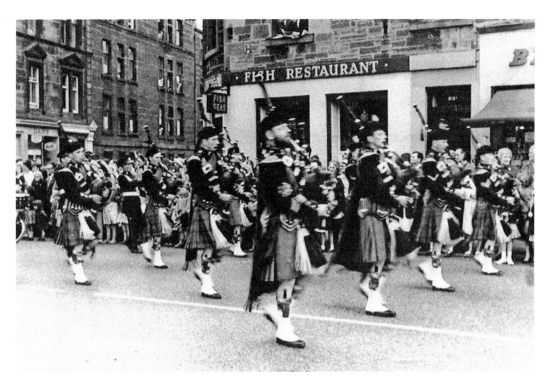

Pipe Band, Great Junction Street
A pipe band passing the popular Morga's Fish Restaurant on the corner of Great Junction Street and Bangor Road. (*Above photograph courtesy of Trevor Roy*)

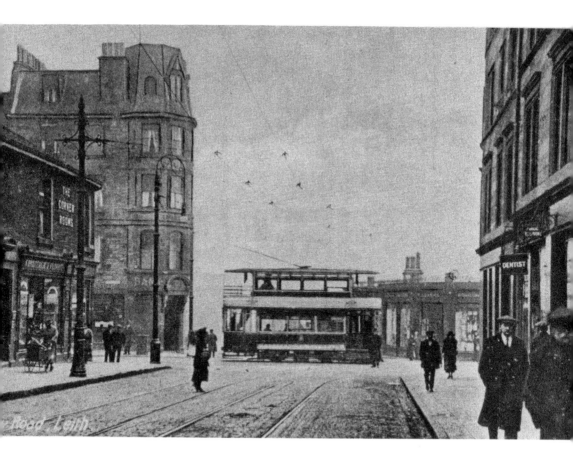

Ferry Road at North Junction Street
The older image shows an electric tram passing on North Junction Street towards Junction Bridge. The Corner Rooms, on the left of the older image, were the venue for many Leith weddings and other social events.

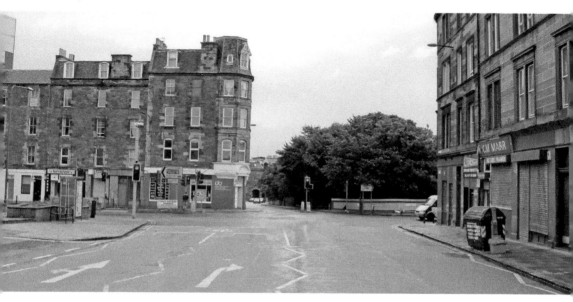

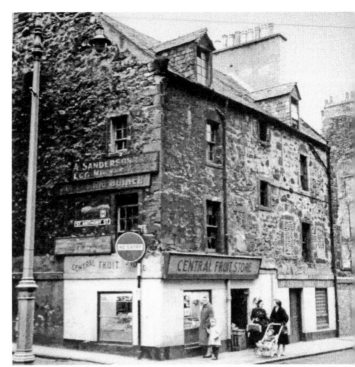

St Anthony Street/Kirkgate
St Anthony Street was one of the Kirkgate's well-known side streets. It took its name from the preceptory of the friars of St Anthony, which was founded in 1418. Much of the street was lost as part of the new Kirkgate development in the 1960s.

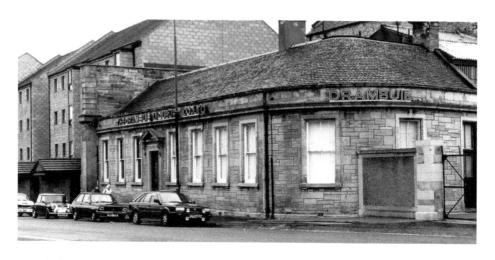

Drambuie, Easter Road

The well-known legend has it that the honey and herb flavoured liqueur, Drambuie, is based on Bonnie Prince Charlie's secret recipe. The first commercial distribution of Drambuie in Edinburgh was in 1910. The office and production were based at the foot of Easter Road. The offices were demolished in the mid 1990s. The wall of the old rail bridge crossing Easter Road can be seen just before the new housing, which was built on the site of the Buttercup Dairy factory. (*Above photograph courtesy of Steven Saunders*)

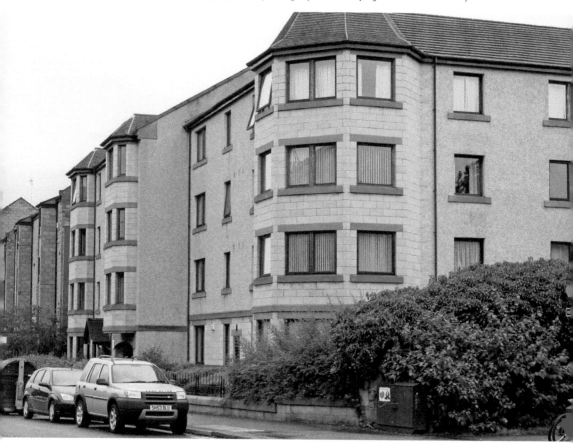

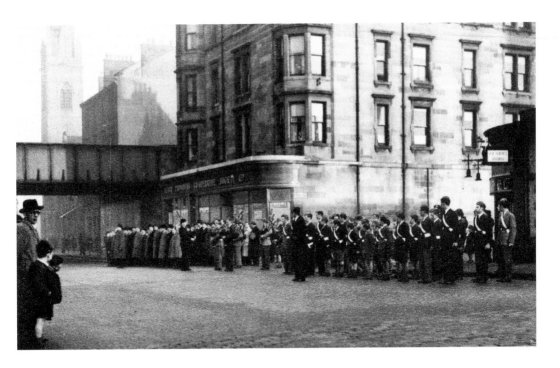

Easter Road, Boys' Brigade Parade

This is such a touching scene from Leith's proud BB history. The photograph shows the 3rd Leith BB, in 1949, near the foot of Easter Road. Not only are the young lads of the brigade on parade, the 'old boys' also stand to attention outside the Leith Provident Co-operative Society – now the Persevere Bar. The rail bridge to Leith Central can be seen cutting through the tenement building. (*Above photograph courtesy of Joanne Baird and Third Leith BB Archives*)

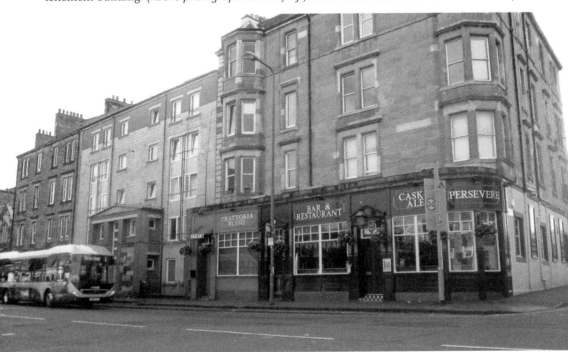

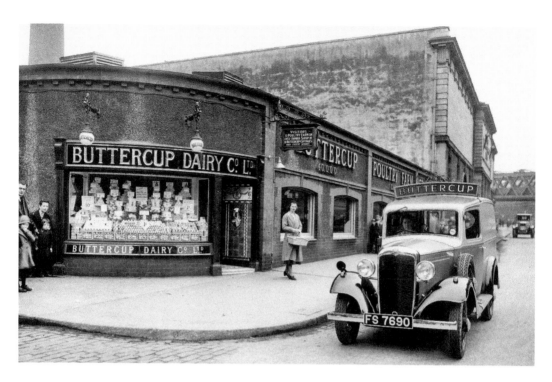

Buttercup Dairy, Easter Road

The Buttercup Dairy Co., founded by Andrew Ewing, established its head quarters in Elbe Street in 1894 and, following rapid expansion, moved to Easter Road in 1915. It was one of the first chain stores, with over 250 shops throughout Scotland. The shops were famous for their beautiful tiled 'girl and cow' murals. (*Above photograph courtesy of Bill Scott www.buttercupdairycompany.co.uk*)

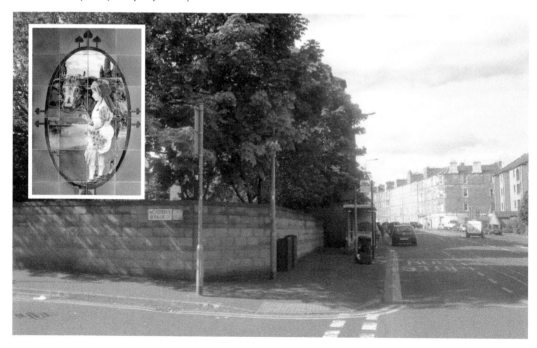

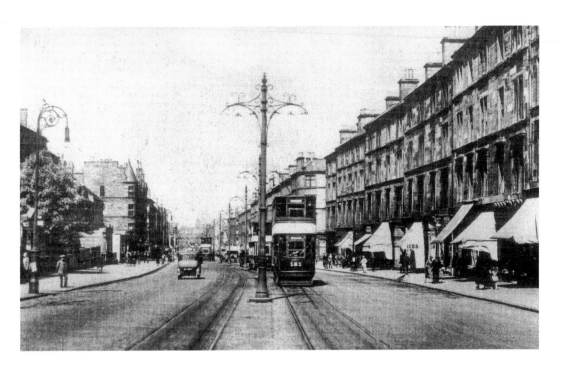

Leith Walk

Leith Walk is now the main route between Edinburgh and Leith. It originated from the defensive earthwork constructed in the mid-seventeenth century to defend the northern approach to Edinburgh against Oliver Cromwell's forces. It developed into a broad footpath for pedestrians only, hence the name Leith Walk. It was established as the main route between Edinburgh and Leith on completion of the North Bridge and, in 1799, had forty oil lamps installed, making it one of the first streets in Scotland to have public street lighting.

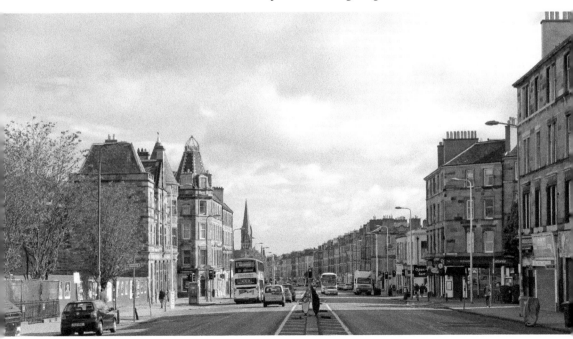

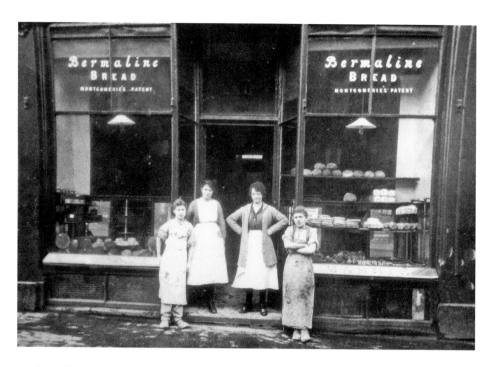

Leith Walk Bakery
The staff of the Leith Walk bakery pose outside the shop in 1920. Adverts for Montgomerie's Patent Bermaline bread are prominent in the windows. (*Above photograph courtesy of Doreen McTeman*)

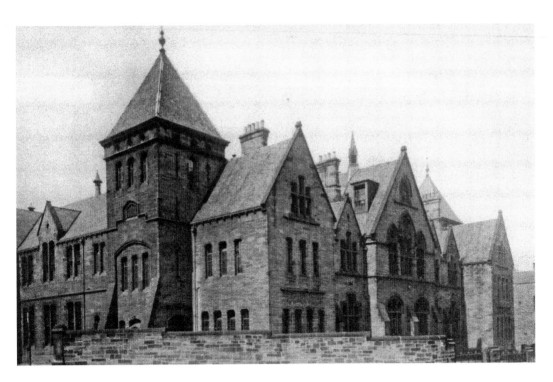

Leith Walk Primary School, Brunswick Road
A large-scale symmetrical boarding school, dating from 1875, built on the Lovers Loan pathway. The school was one of many built in Scotland following the passing of the Elementary Education Act in 1870. The act made education compulsory for children from age five to twelve. A Victorian schoolroom is now located in the grounds of the school.

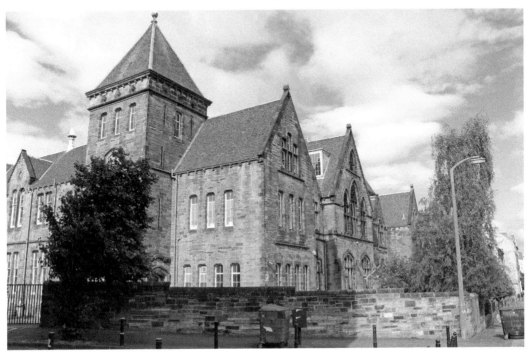

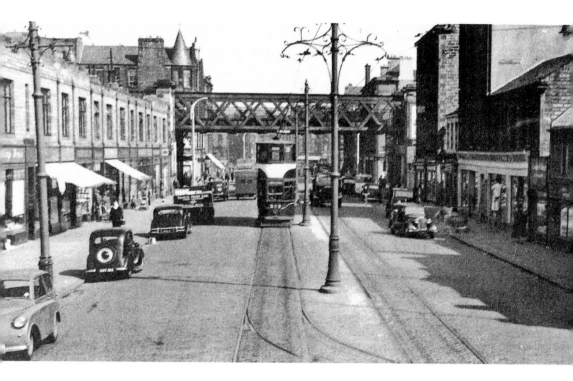

Leith Walk Railway Bridge

The lattice girder bridge over Leith Walk carried the Caledonian Railway Leith Branch. It was removed in September 1980. A much changed traffic scene is shown over the decades in these two images. (*Above photograph courtesy of Bill Robertson*)

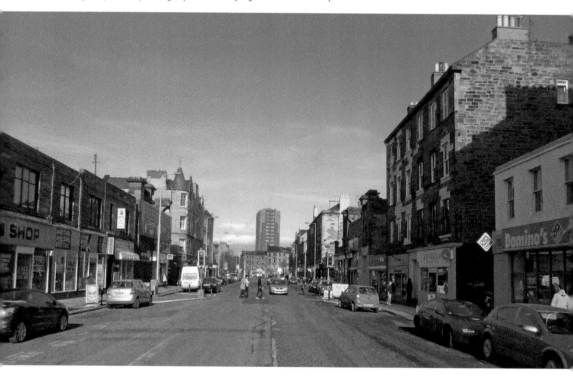

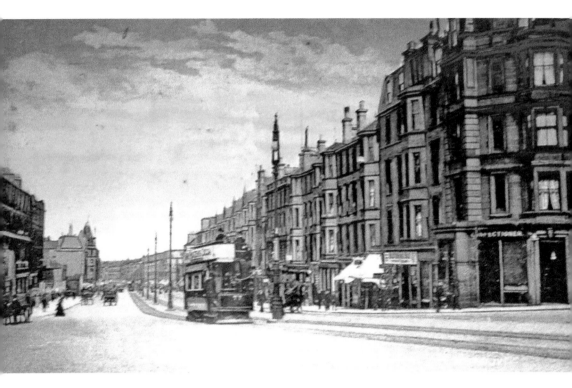

Leith Walk at Elm Row
View down Leith Walk, the main approach to Leith from the Edinburgh's city centre.

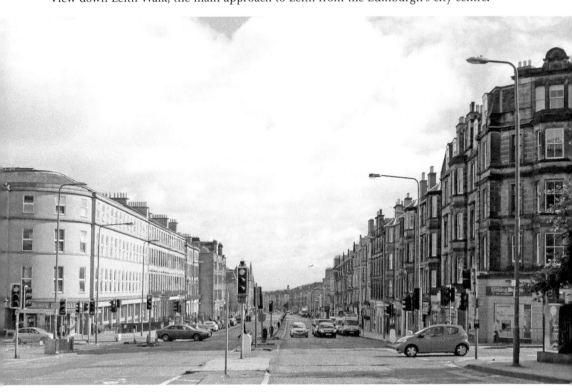

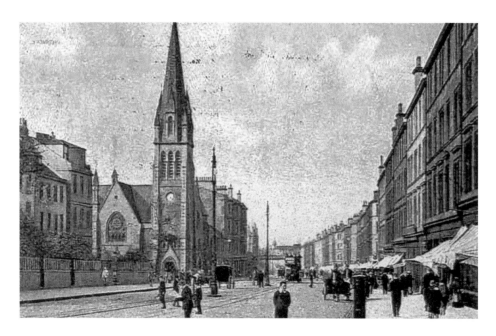

Pilrig Muddle, Leith Walk

Pilrig church is a dominating landmark on Leith Walk, and marks the historic boundary between Leith and Edinburgh. In 1905, when the newly created Leith Corporation Tramways pioneered the use of electric traction, an anomaly appeared that would take nearly twenty years, and the unification of two separate autonomous burghs, to sort out. Since Edinburgh's system was predominantly cable-run and Leith's was electrified, passengers travelling either way along Leith Walk were forced to change vehicles at the Pilrig city boundary. The hugely unpopular merger between the two burghs, in 1920, formed the catalyst for the upgrade of the Edinburgh network to an electric system. Electric trams finally crossed the frontier on 20 June 1922, and the chaotic interchange known as 'the Pilrig muddle' was eradicated.

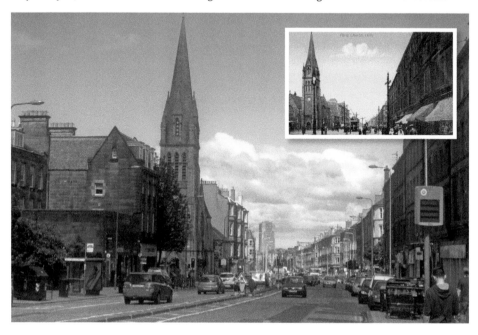

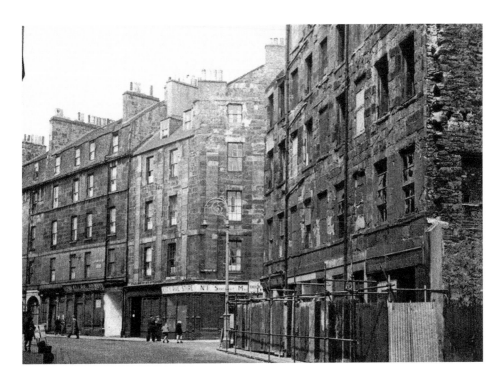

Bridge Street

Bridge Street was one of the main arteries of North Leith, leading to the Upper Drawbridge. It was a densely populated tenement area, which was fondly remembered for its sense of community.

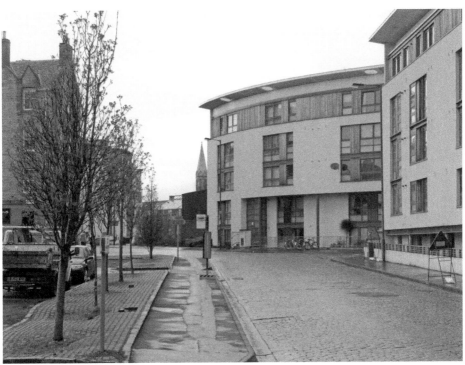

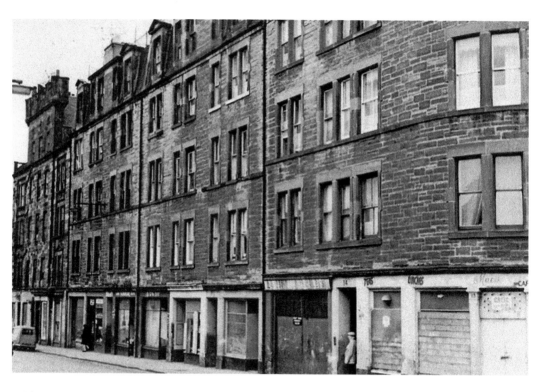

Bridge Street

These images of Bridge Street looking towards the Water of Leith show the radical change in the character of the area.

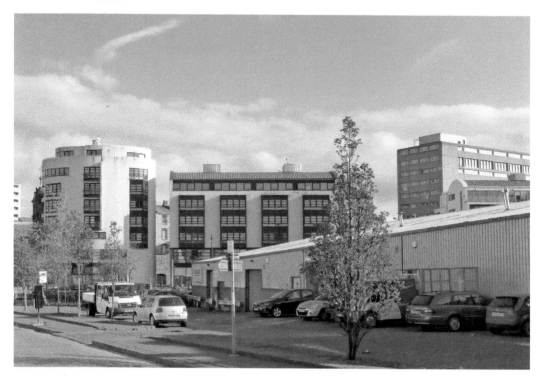

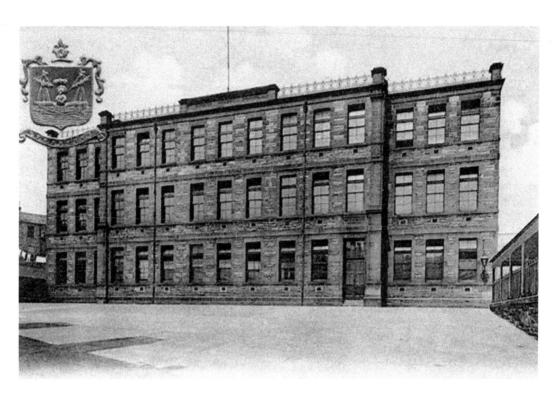

Couper Street School

The original gateposts of Couper Street School frame the new housing that occupies the site. The school building dated from 1890.

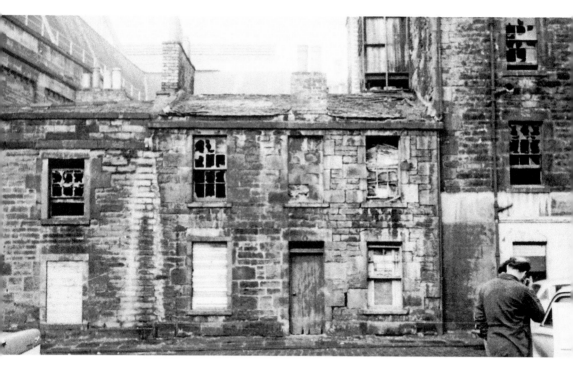

Glover Street

Glover Street ran from Manderston Street directly through to Duke Street. That was until Leith Central station was built in 1898, at which point the street was cut in two by the huge station leaving a small stump off Duke Street. Today, supermarket tills mark the line where this street ran.

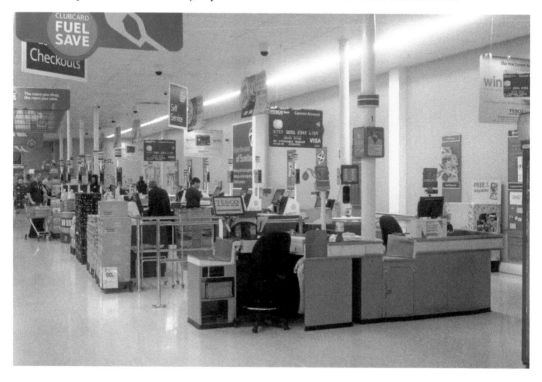

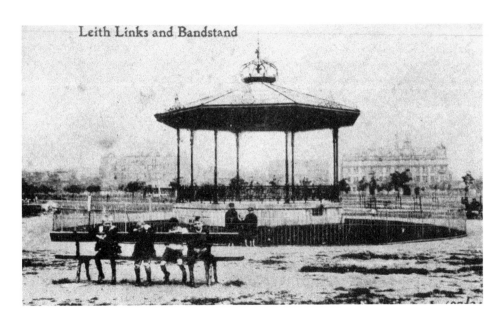

Leith Links

Leith Links were part of a larger area of common land that stretched along the coast, including part of Seafield. Links is Scots, meaning 'sandy ground with hillocks and dunes', and the present artificial flatness dates from about 1880, when it was remodelled into a formal park. These improvements removed most of the world's oldest golf course, which is mentioned as early as 1456, when King James II imposed a ban on the game because it disrupted archery practice on the Links. The first rules of golf, which are the basis of the modern game, were drawn up in 1744 for use on the Links by Leith's Honourable Company of Edinburgh Golfers. The two mounds, the Giant's Brae and Lady Fyfe's Brae, at the western end of the Links, are believed to be artillery mounds. Somerset's Battery and Pelham's Battery were used during the 1560 siege of Leith. The Links were also the last resting place of hundreds of casualties of the 1645 plague outbreak, which wiped out half of the population of Leith.

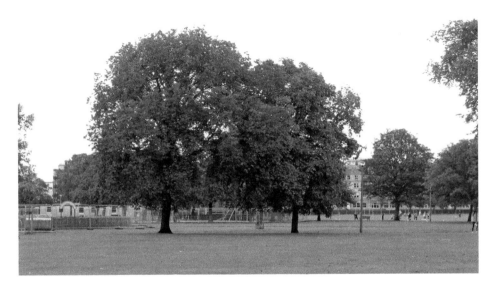

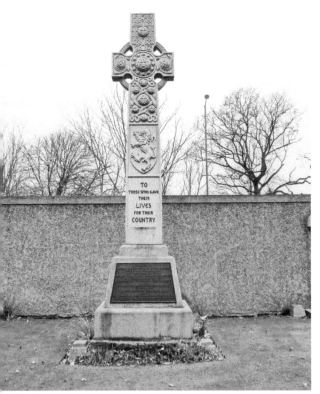

The Gretna Disaster

'The whole town was stricken with grief, and sore did she mourn her fallen sons.' The incident that most affected Leith during the First World War was the terrible fate of its own battalion, the 7th Royal Scots, while on its way to join the fighting. The Gretna Rail disaster occurred on 22 May 1915 at Quintinshill, near Gretna, due to an error by a signalman. There were 226 fatalities, the greatest loss of life ever for a rail crash in Britain. The dead included 214 soldiers from the Leith Battalion of the Royal Scots, on their way to Gallipoli. Of the dead, 107 were brought to the former Drill Hall in Dalmeny Street, which was used as a temporary mortuary. Pilrig Street was lined with crowds of people for the funeral procession to Rosebank Cemetery, which took three hours to pass. An annual remembrance service is held at the Memorial in the Cemetery.

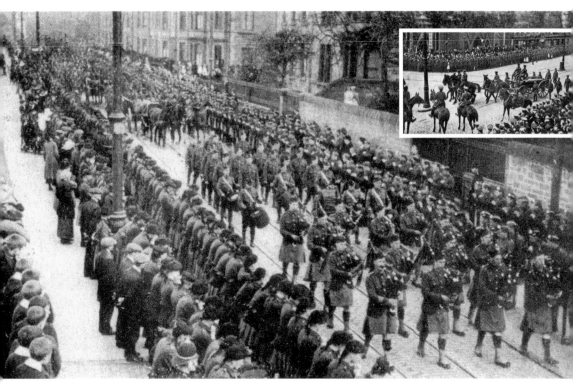

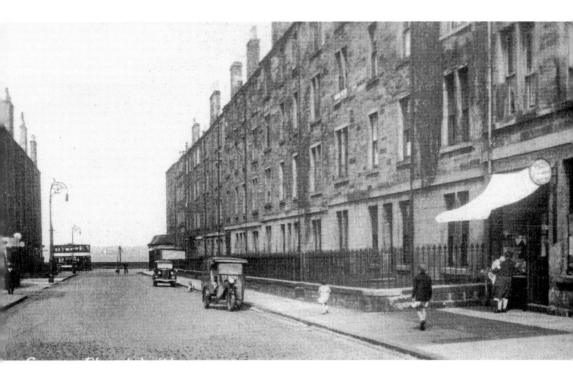

George Street

George Street in Leith was laid out around 1812, and was named for George IV. In 1966, to avoid confusion with George Street in Edinburgh, it was renamed North Fort Street. In the older image a tram is travelling on Lindsay Road. The view of the sea, at the end of the street in the older image, is now blocked by the Chancelot Mill. (*Above photograph courtesy of Old Leithers*)

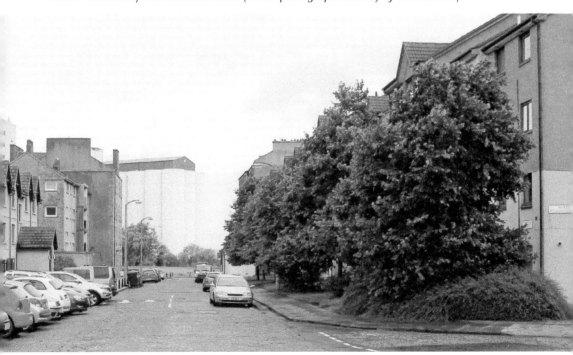

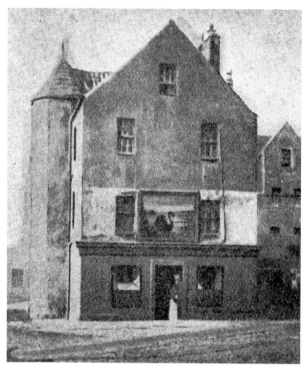

Black Swan

The original Black Swan was the village inn of North Leith, allegedly frequented by old salts and pirates spinning tales of the high seas. It was rebuilt in 1892 and continued trading as the Black Swan. Over time, the tales changed to those of the perils of whale hunting in the icy seas of South Georgia. In recent years, the Black Swan forfeited its name, which it held for generations, and is now the popular Roseleaf Café.

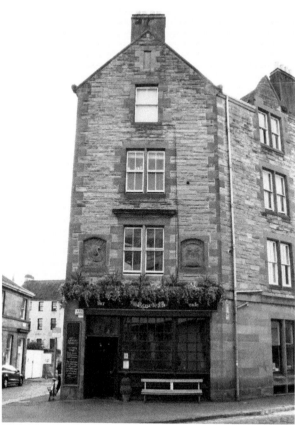

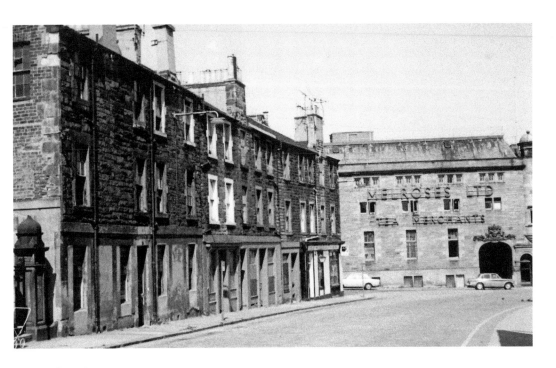

Coburg/Couper Street

The older image shows the frontage of the headquarters and warehouse of Melrose's Ltd tea and coffee merchants at Nos 55–57 Couper Street. Melrose's was a popular brand and they had a number of shops in the Edinburgh area. Andrew Melrose established the company in 1812 and, when the tea clipper *Isabella* landed a consignment of tea at Leith in 1835, Melrose became the first tea merchant outside of London to import tea into Britain. The warehouse, which dates from around 1900, has been converted into flats.

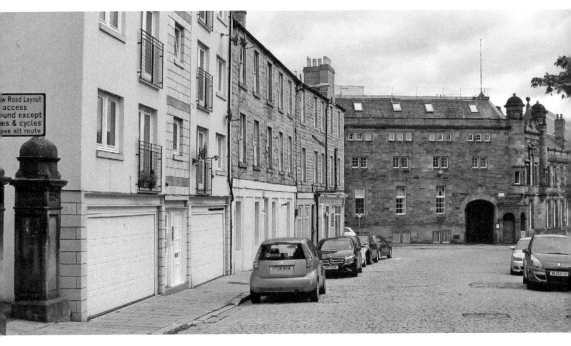

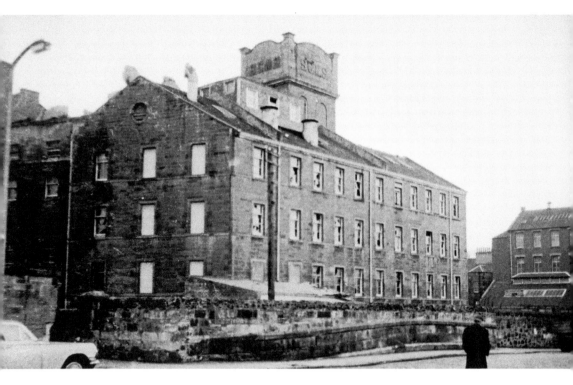

South Fort Street
The Scottish Co-operative Wholesale Society mill. The arched wall is the old railway bridge crossing over South Fort Street. The line ran onto the Citadel Station via the tunnel under Coburg Street.

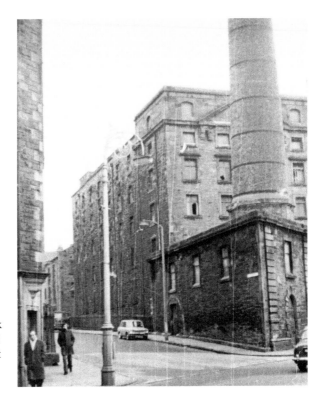

Tod's Flour Mill, Commercial Street
Tod's Flour Mill, and its towering chimney, was a significant industrial landmark at the west end of Commercial Street. The Mill was the largest in the port. The original mill was burned down in 1874.

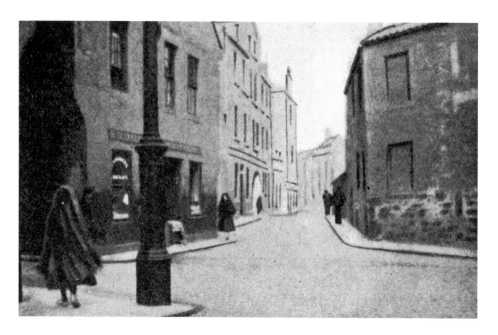

Meeting House Green

Meeting House Green took its name from a building in which dissenting Presbyterians worshipped in the late seventeenth century. It was also the site of Leith Soap Works, which were opened in 1619 by a Nathaniel Uddart. Uddart, whose father had been Provost of Edinburgh, was granted the monopoly of soap making in Scotland for twenty-one years, on payment of an annual £20 duty to the Crown. He erected 'a goodly work' in Leith for the purpose. Until then, foreign soap, mostly imported from the Low Countries, was all that was available. However, it does not seem to have been a prosperous undertaking, as not many people were given to regular washing at the time. Meeting House Green, and the old soap works, are long lost under the foundations of modern housing and a car park, between the Cables Wynd and King Street.

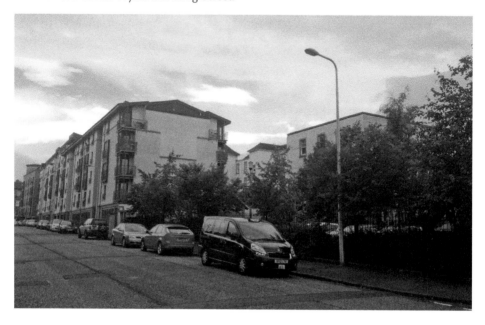

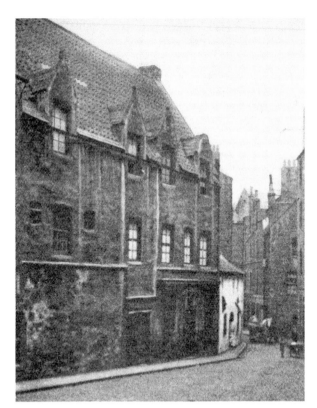

Old Mansion, Queen Street
The mansion house in the old image dated from 1615. In the late 1600s, the street was known as the Paunch or Pudding Market. It was renamed Shore Place in 1966, to avoid confusion with Queen Street in the New Town.

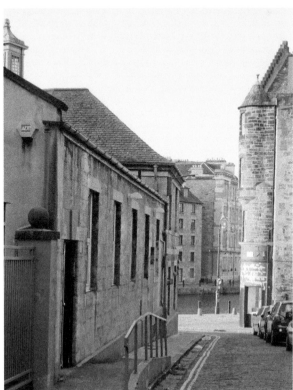

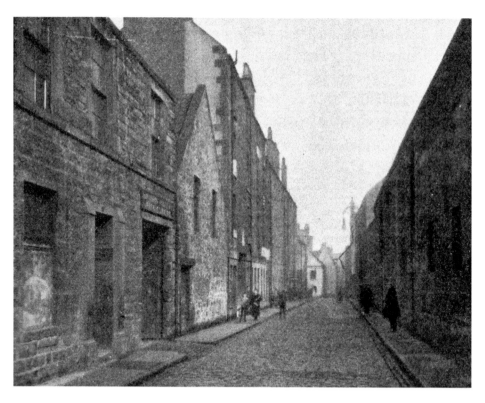

Cable's Wynd

Cable's Wynd was curiously believed to be named after Henry Capell, a former veteran of Oliver Cromwell's army, who set up business in Leith as a maltman and brewer in the mid-1600s.

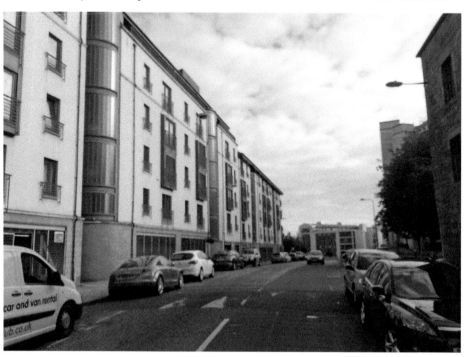

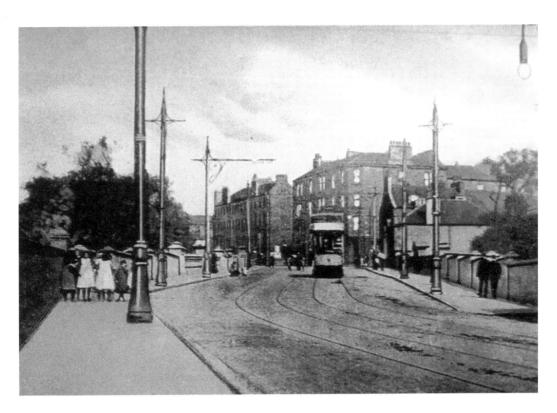

Bonnington Bridge

A tram crosses Bonnington Bridge in the earlier image. The current Bonnington Bridge dates from 1902/03, and replaced an earlier bridge that dated from 1812.

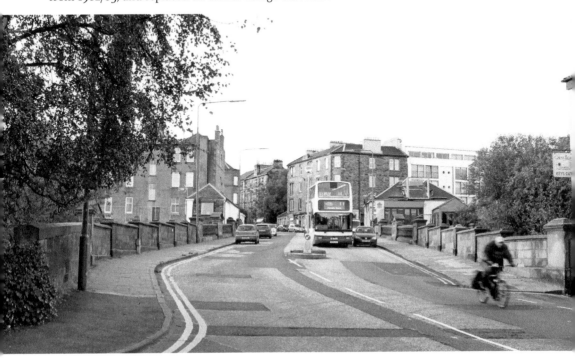

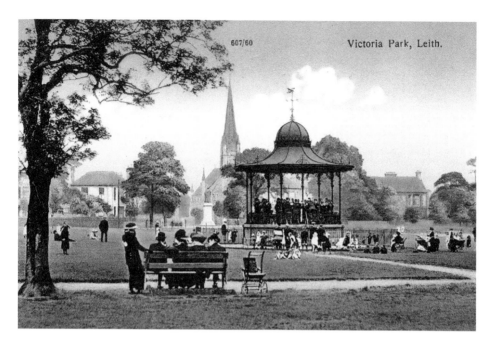

Victoria Park

Victoria Park was known as Raimes Park before its name change in 1919 in honour of Queen Victoria. The statue of King Edward VII was erected in 1913. The bandstand in the older image is long gone.

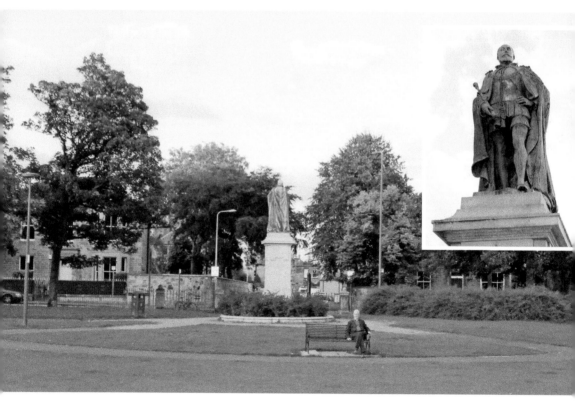

Glass House, Salamander Street
Glass manufacturing was once one of Leith's thriving industries. The furnaces used in glass production can be seen in the older image of Salamander Street. The street takes its name from the legend of the Salamander – the fire proof lizard.

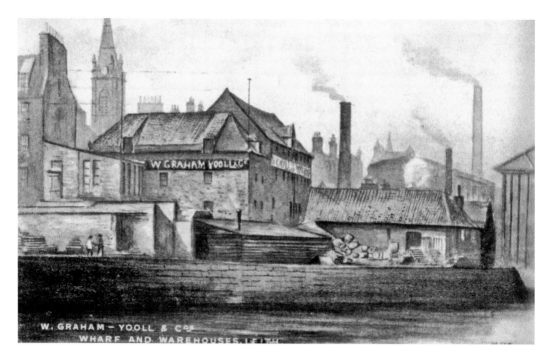

W. Graham-Yool & Co., Sheriff Brae

W. Graham-Yool & Co.'s pier and warehouse were at the lower end of Sheriff Brae, adjoining where the east abutment of the old Brig o' Leith was located. W. Graham-Yool & Co. had numerous business interests in Leith. The pier is seen here close to the company warehouses, which were located at the lower end of Sheriff Brae, close by the site of the old Brig o' Leith.

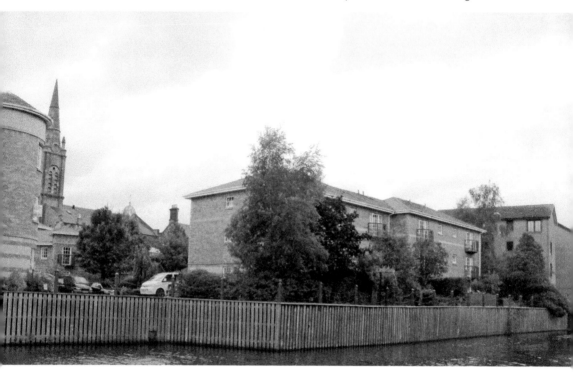

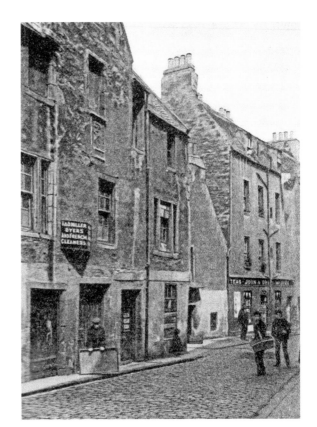

Rotten Row

Rotten Row was the former name of Water Street. The name is said to derive from the Old French *raton*, a rat, implying a rat-infested group of houses. It was renamed the more salubrious sounding Water Lane around 1777, and Water Street in 1872. This derived from the former water reservoir at the corner of the street and Tolbooth Wynd.

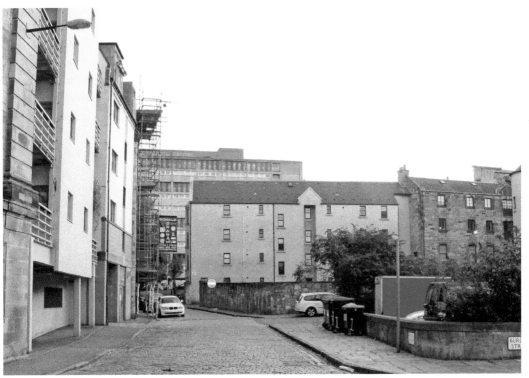

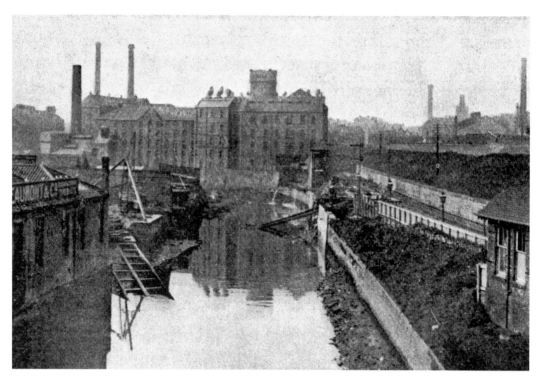

Junction Mills
The industrial complex of Junction Mills, close by the Water of Leith, has long disappeared, and has been replaced by a more green landscape.

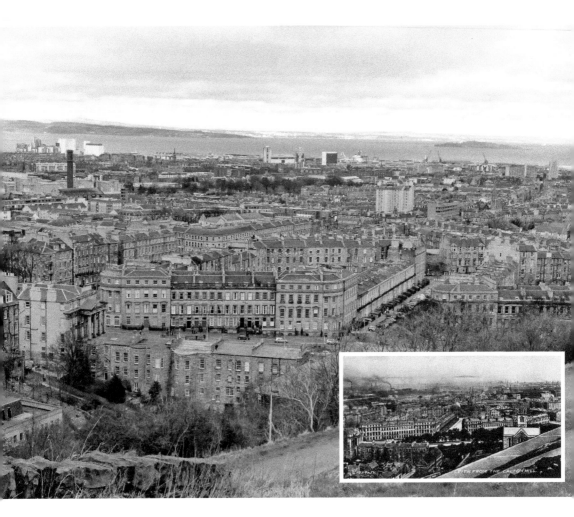

Leith from Calton Hill

There is a spectacular contrast between the old industrial Leith and the modern town in this view from Calton Hill.

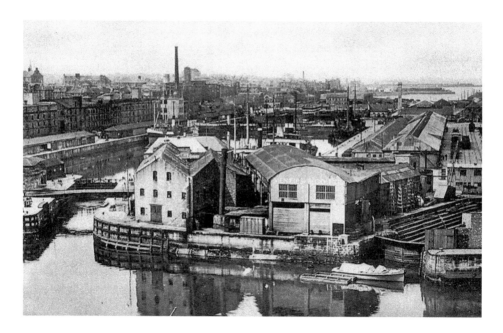

Leith Harbour

Leith Docks have a long history. The original harbour at Leith was a quay at the mouth of the Water of Leith. This was upgraded by the East and West Old Docks in the early nineteenth century. The work was so expensive that Edinburgh agreed to the town's independence in 1833 to avoid paying for it. The Victoria Dock followed in 1847–51, the Prince of Wales Graving Dock was added in 1858, and the Albert Dock, which was the first in Scotland with hydraulic cranes, was completed in 1869. The Edinburgh Dock was built for coal delivery in 1877–81, and the final wet dock – the Imperial Dock – was completed in 1896–98. A second large graving dock, the Alexandra, was added beside the Prince of Wales Dock in 1896. The Forth Ports Authority was established in 1968 to control the ports on the Forth, with their headquarters at Leith.

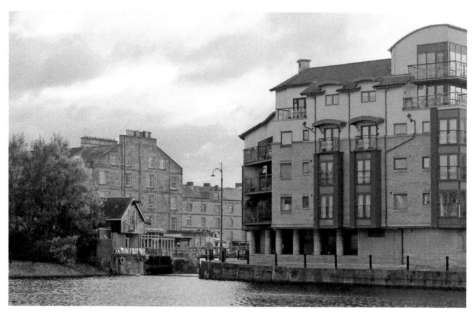

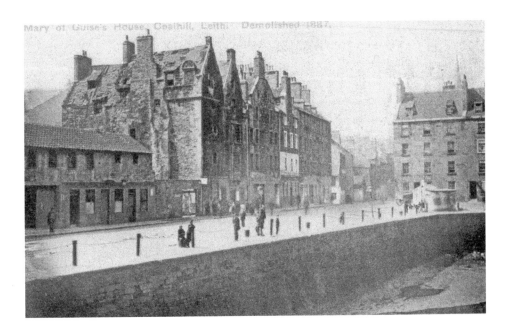

Coalhill

In 1548, during the civil war between Mary of Guise and the Scottish Protestant Lords, the Queen Regent moved the seat of government to Leith, built fortifications, and held the town for twelve years with support from France. The fortifications ran from the west end of Bernard Street south–east, to the junction of the present Maritime and Constitution Street, and south to the foot of Leith Walk, returning to the Shore along the line of what is now Great Junction Street. Mary of Guise died in June 1560, and the Siege of Leith ended with the departure of the French troops. There is some debate about the location of Mary of Guise's residence in Leith, which is normally given as being in Water Street (Rotten Row). This old postcard is possibly erroneous in its description.

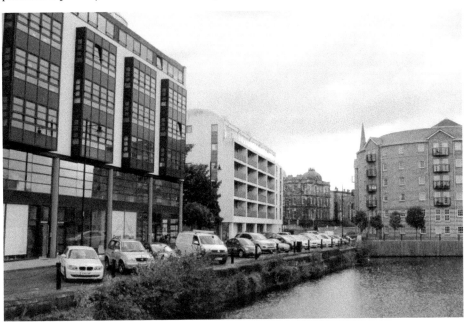

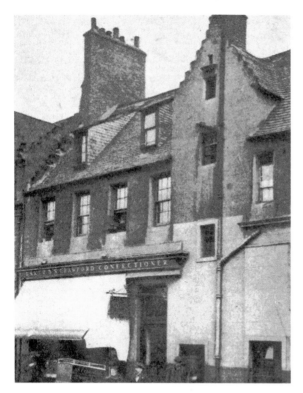

Crawford's Shop, the Shore
This quaint old building was the shop premises of William Crawford & Sons, the oldest biscuit manufacturers in Scotland, which was established in 1813. The Crawford's factory, on Elbe Street, employed hundreds of Leithers at one time. Biscuit making was one of Edinburgh's, and Leith's, most important industries by the middle of the twentieth century – part of Edinburgh's three industrial 'Bs': biscuits, brewing and books.